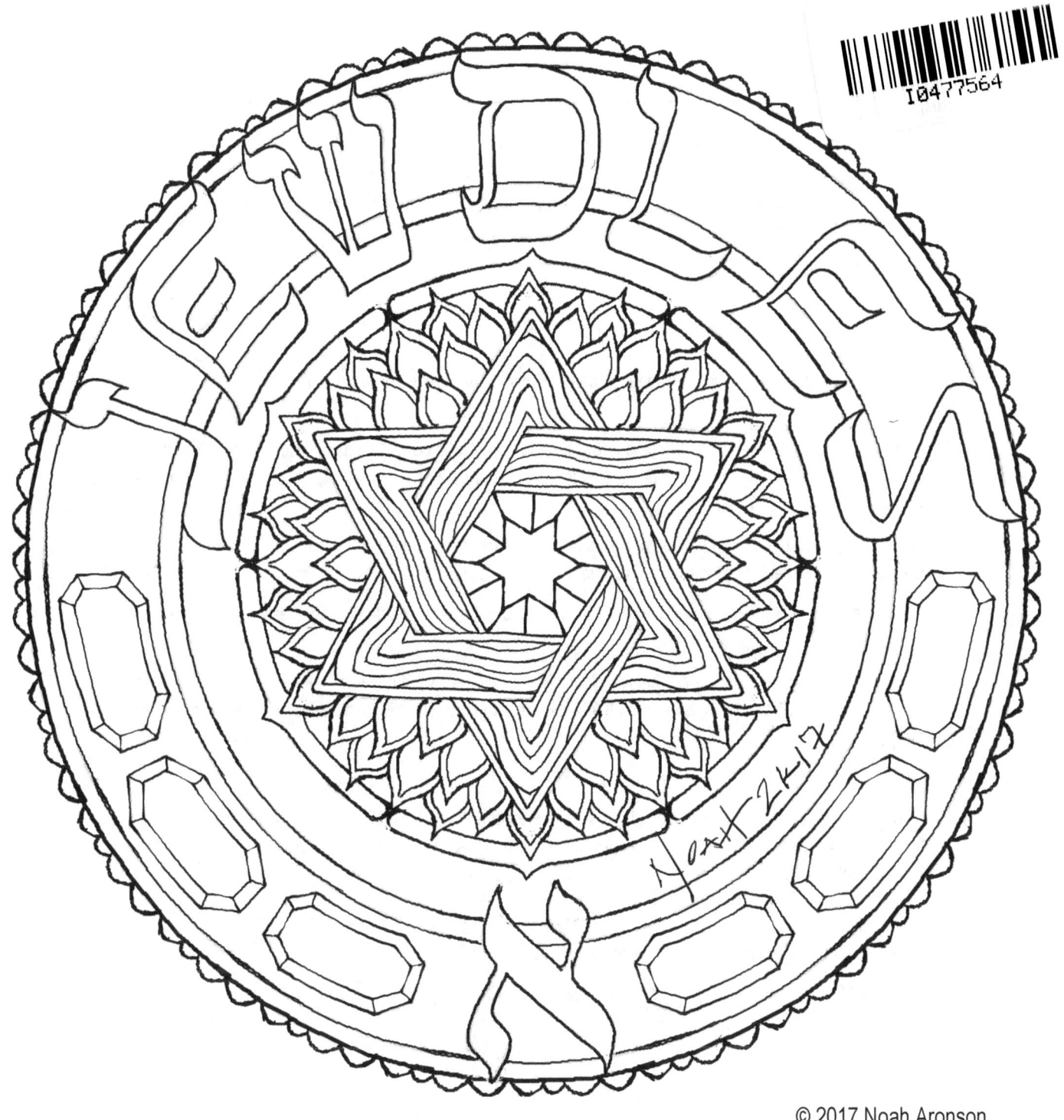

© 2017 Noah Aronson

JEWISH DOODLES
FOR YOU TO COLOR

Featuring Artwork by Noah Aronson

> *This book is dedicated to my family and my tribe!*
> *May you never be afraid to be who you are and*
> *may you always find comfort in what you see and create!*

Why a coloring book?

As an artist, I often find myself reaching for pen and paper, or iPencil and iPad to sketch my tension away through "visual meditation"...

As a Jewish Artist, I have turned to doing what I call "Jewdles" (aka Jewish themed doodles) as "visual meditation" to both release my tension, and to meditate as I think about the symbols I sketch, or the Hebrew words I draw, or the patterns I repeat...

As an adult, I watch the throngs of other adults buying and using adult coloring books and markers or colored pencils as "visual meditation" to exercise their tension demons away...

As a parent, I have surrounded my children with coloring books, pages, and sketch diaries for them to use as "visual meditation"

As a 5th grade Hebrew teacher at The Temple in Atlanta, GA, I always have pop music playing and Jewish coloring pages available for my students when they arrive to help "visually meditate" and get them ready for their morning!

One day, I thought to myself, why can't I put all of this together? So I started creating coloring pages for my family, for my friends, for my students, and for myself! As I started to collect them I decided I needed to publish them into a book.

That's what this is, my first Jewdles coloring book!

Jewdles Alef: Jewish Doodles for You to Color

© 2017 Noah Aronson

Please note, if you are a Jewish Educator, and you would like to copy pages from this book to use in your classes for your students to color in class, you are free to do so. Any other reproduction of the images in this book without prior written permission are strictly prohibited!

If you enjoy this coloring book, please follow me on Facebook at http://facebook.com/Noah.Artist and let me know you would like to see more!

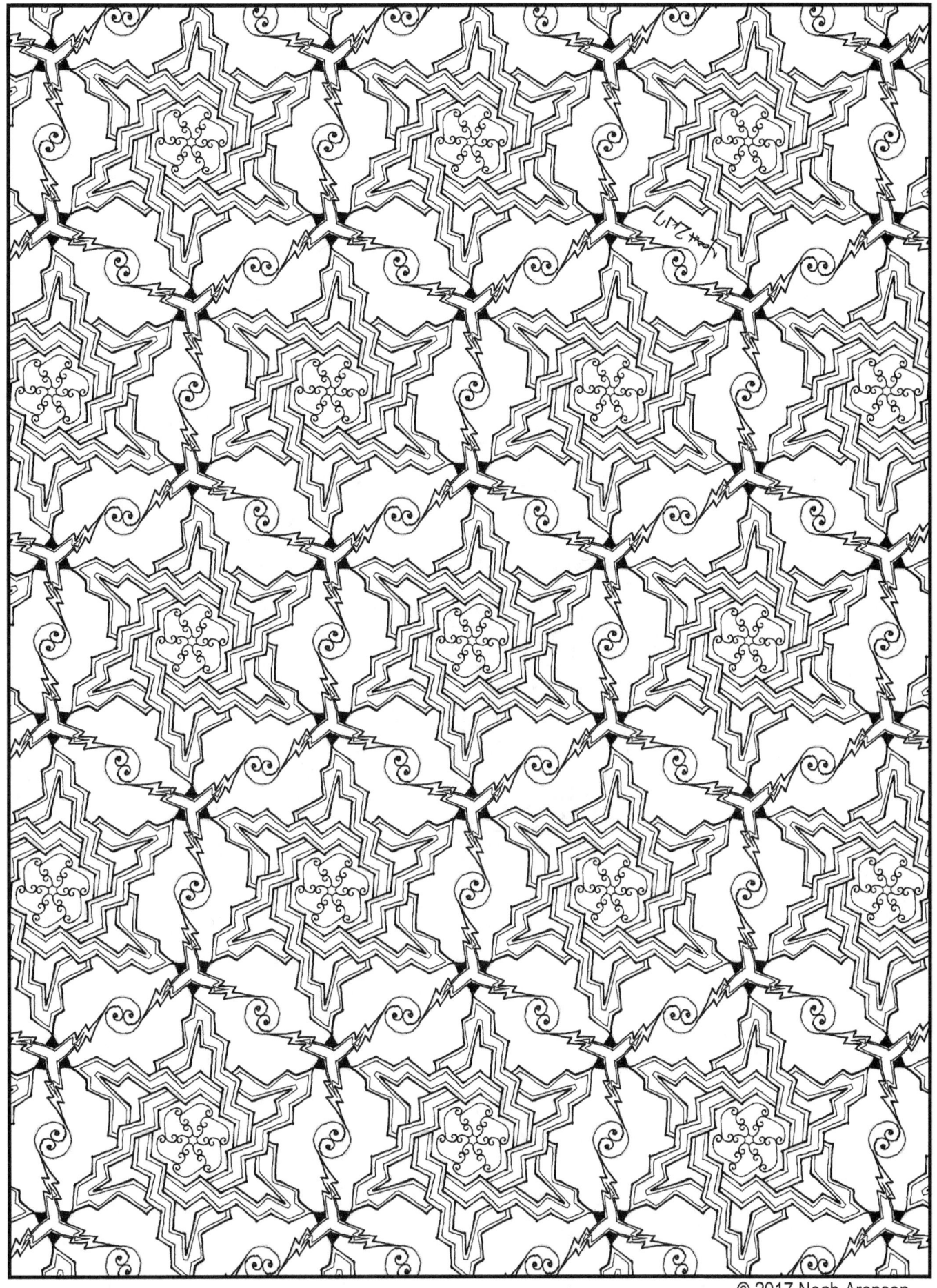

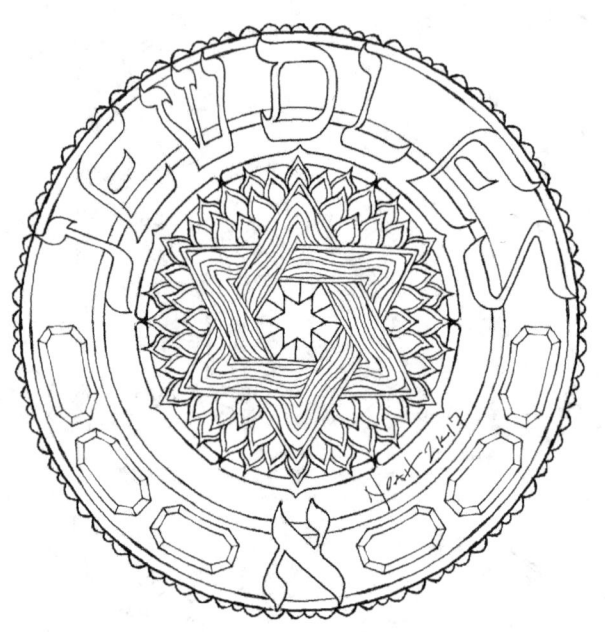

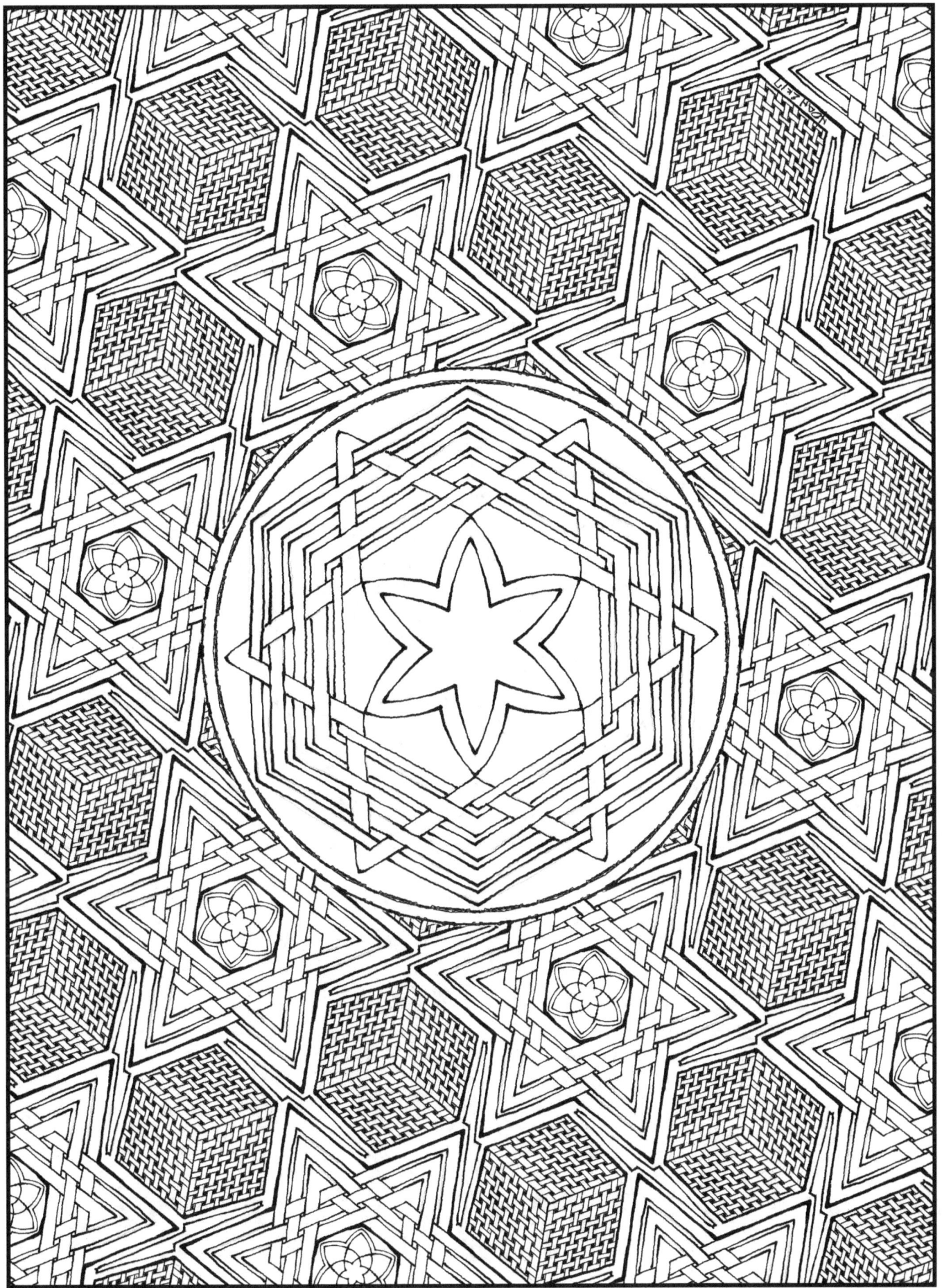

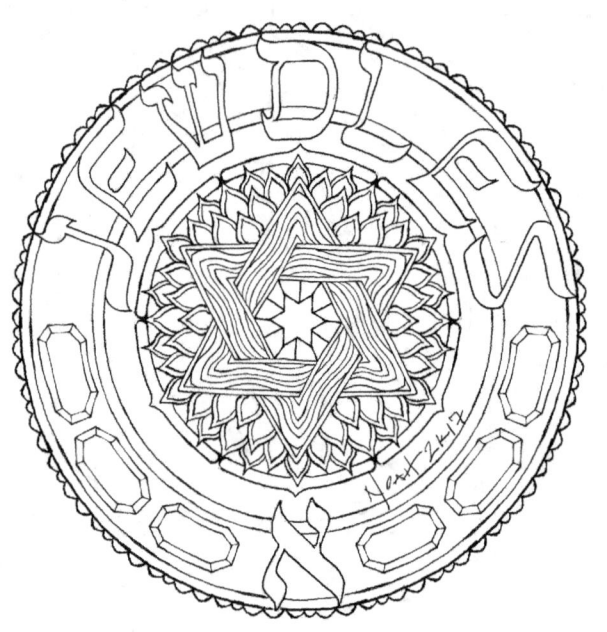

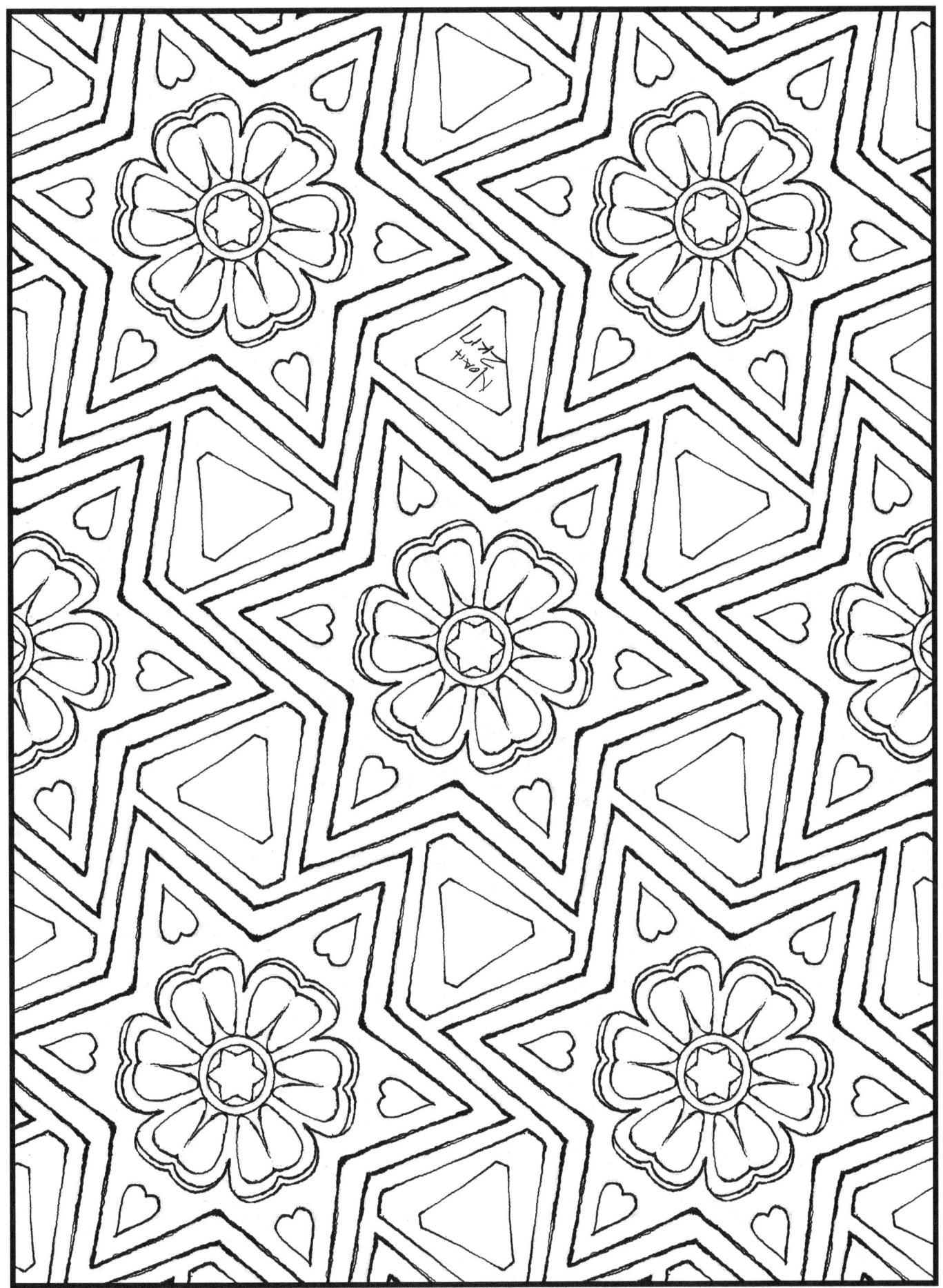

© 2017 Noah Aronson

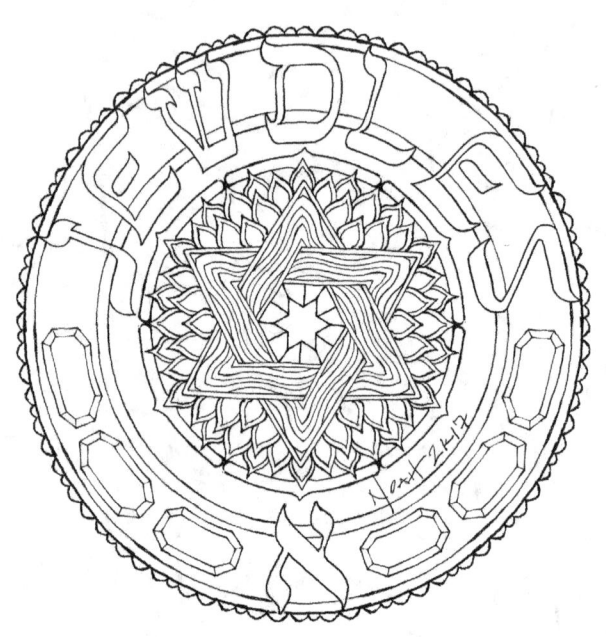

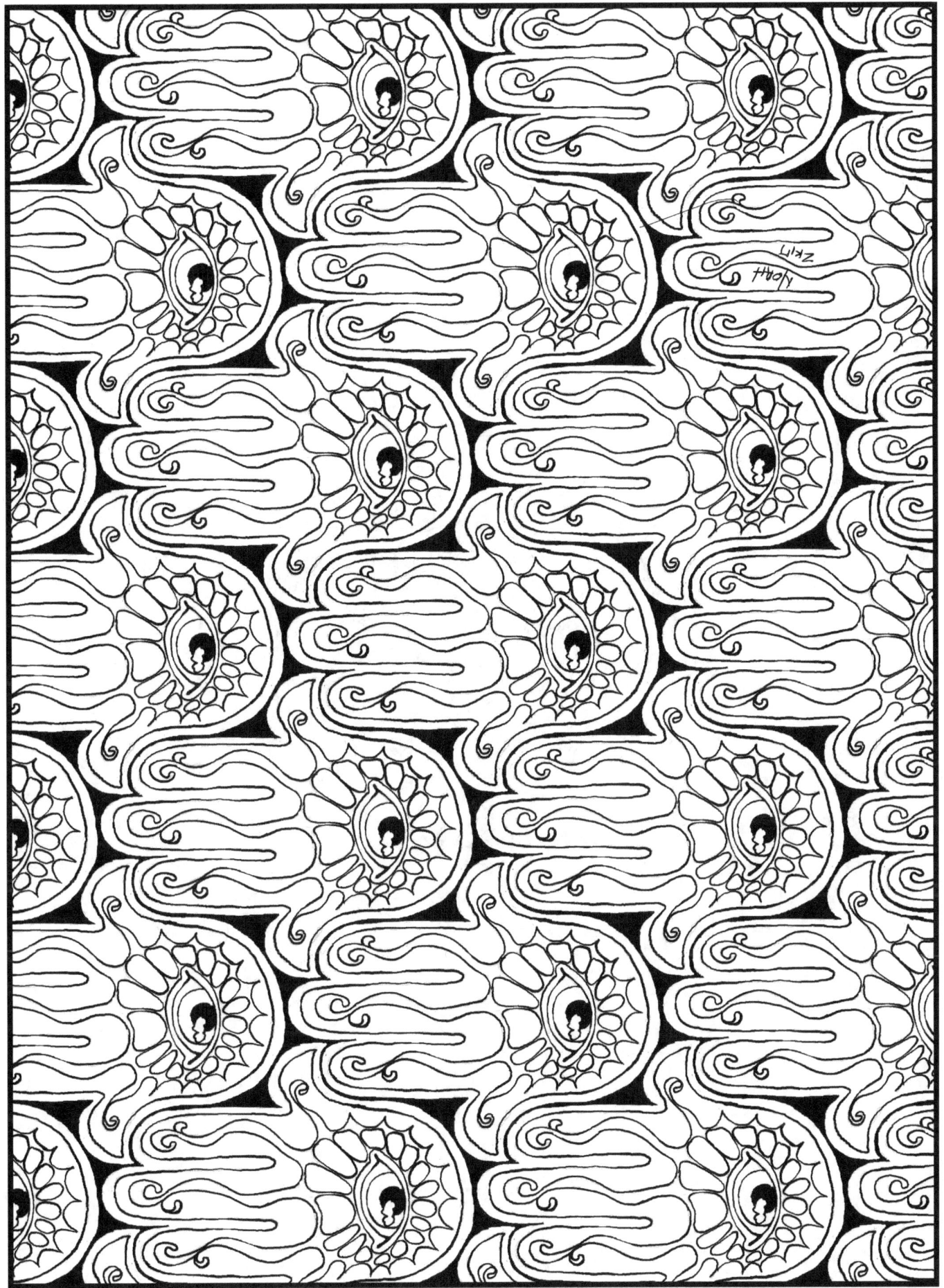

© 2017 Noah Aronson

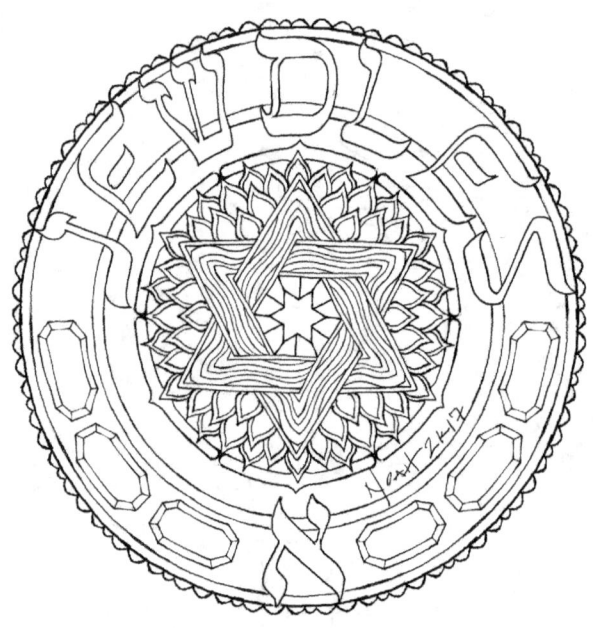

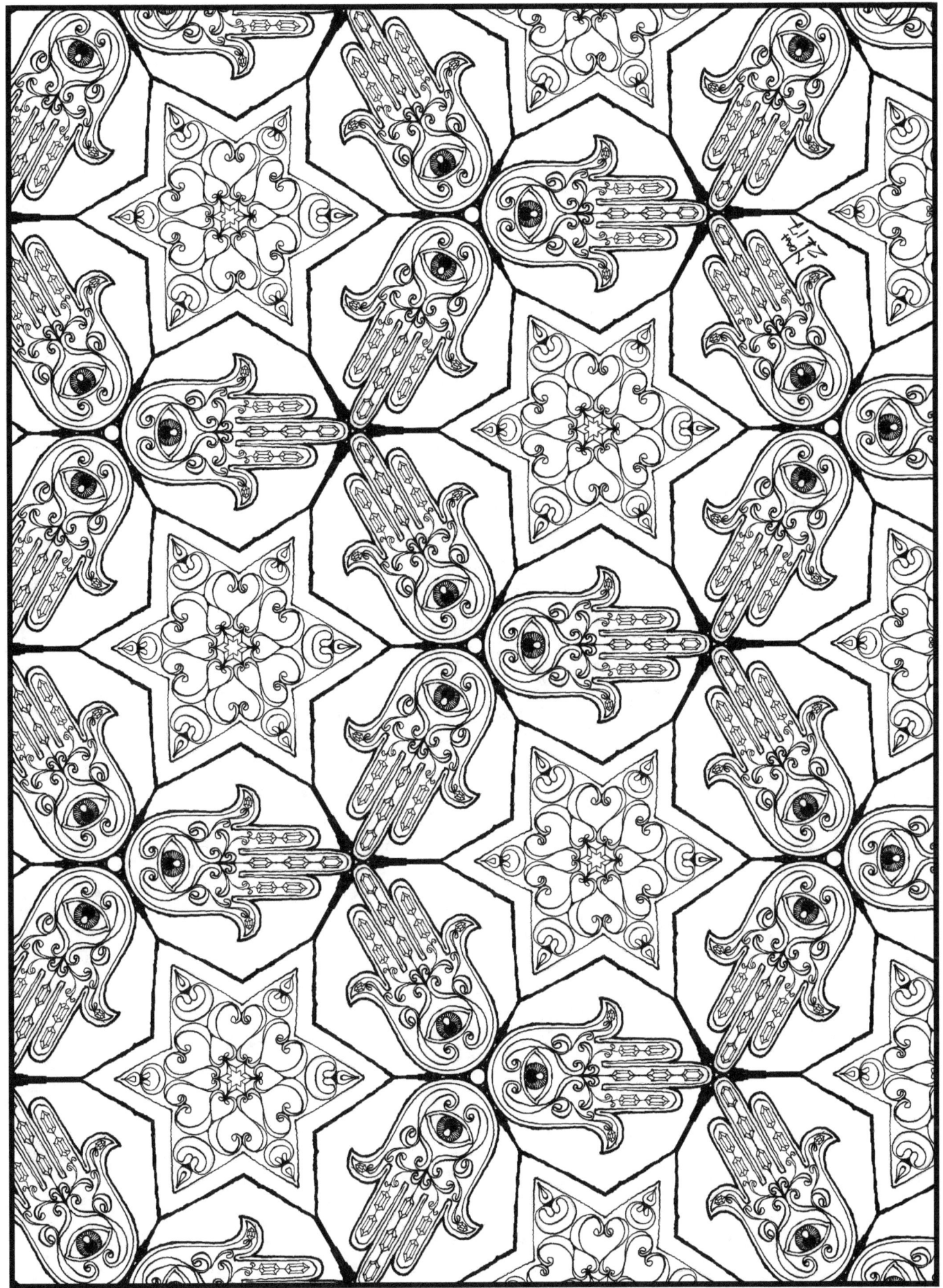

© 2017 Noah Aronson

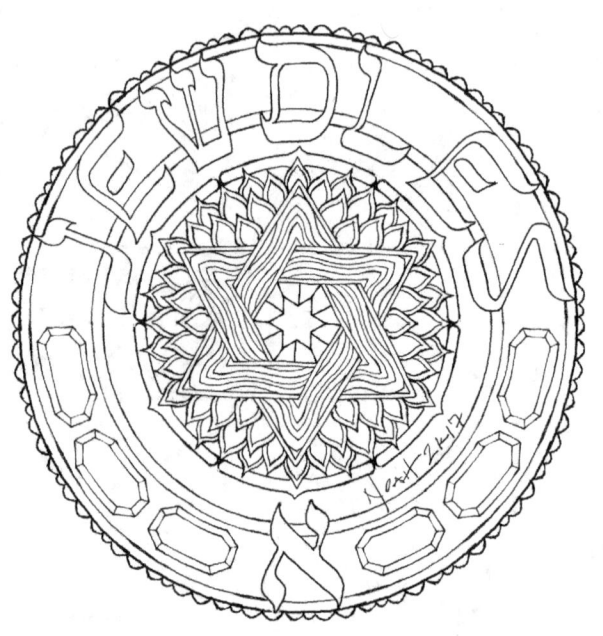

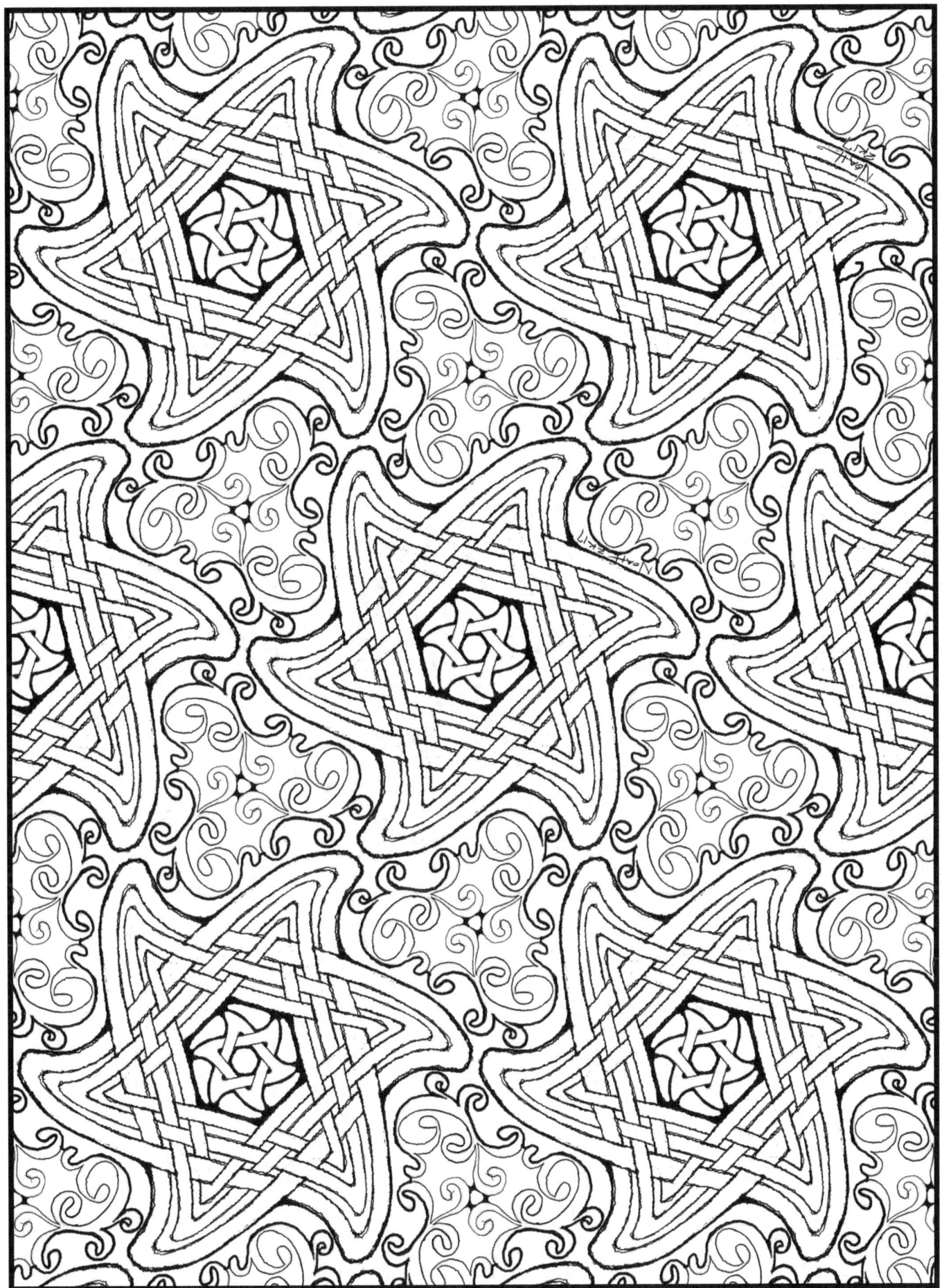

© 2017 Noah Aronson

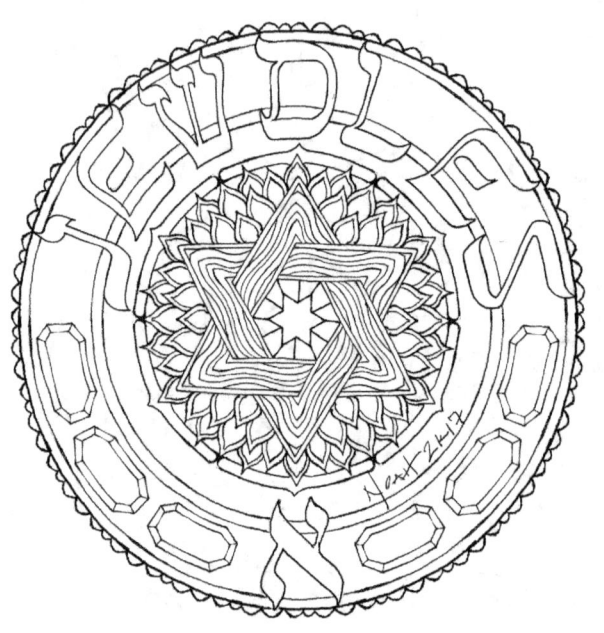

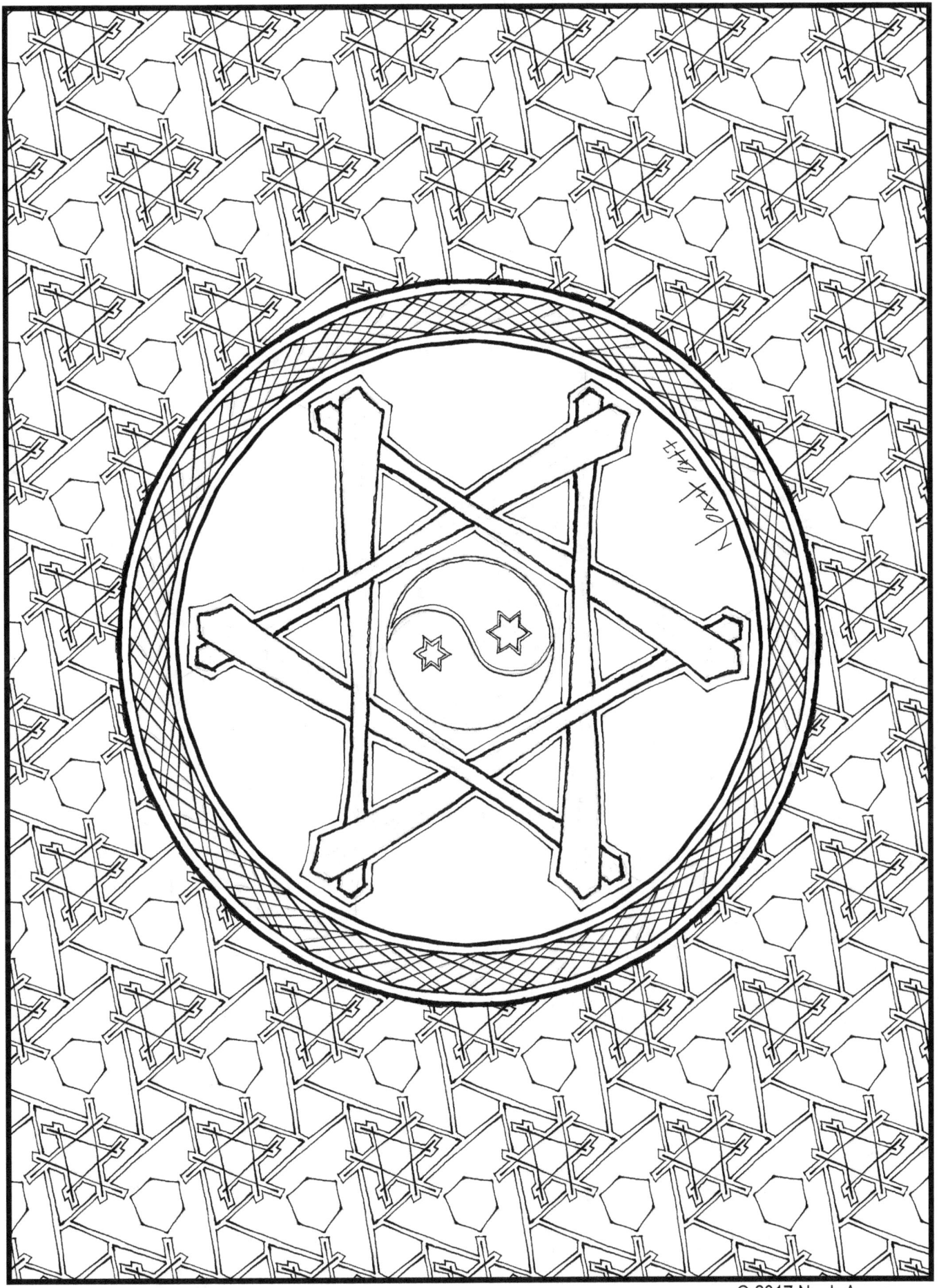

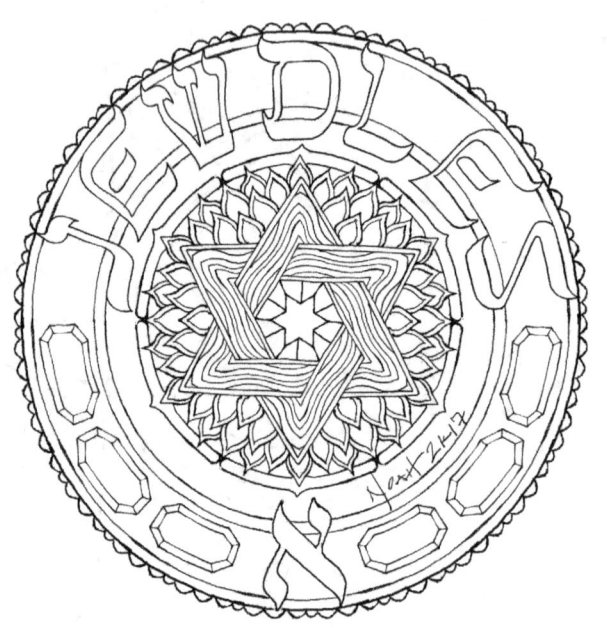

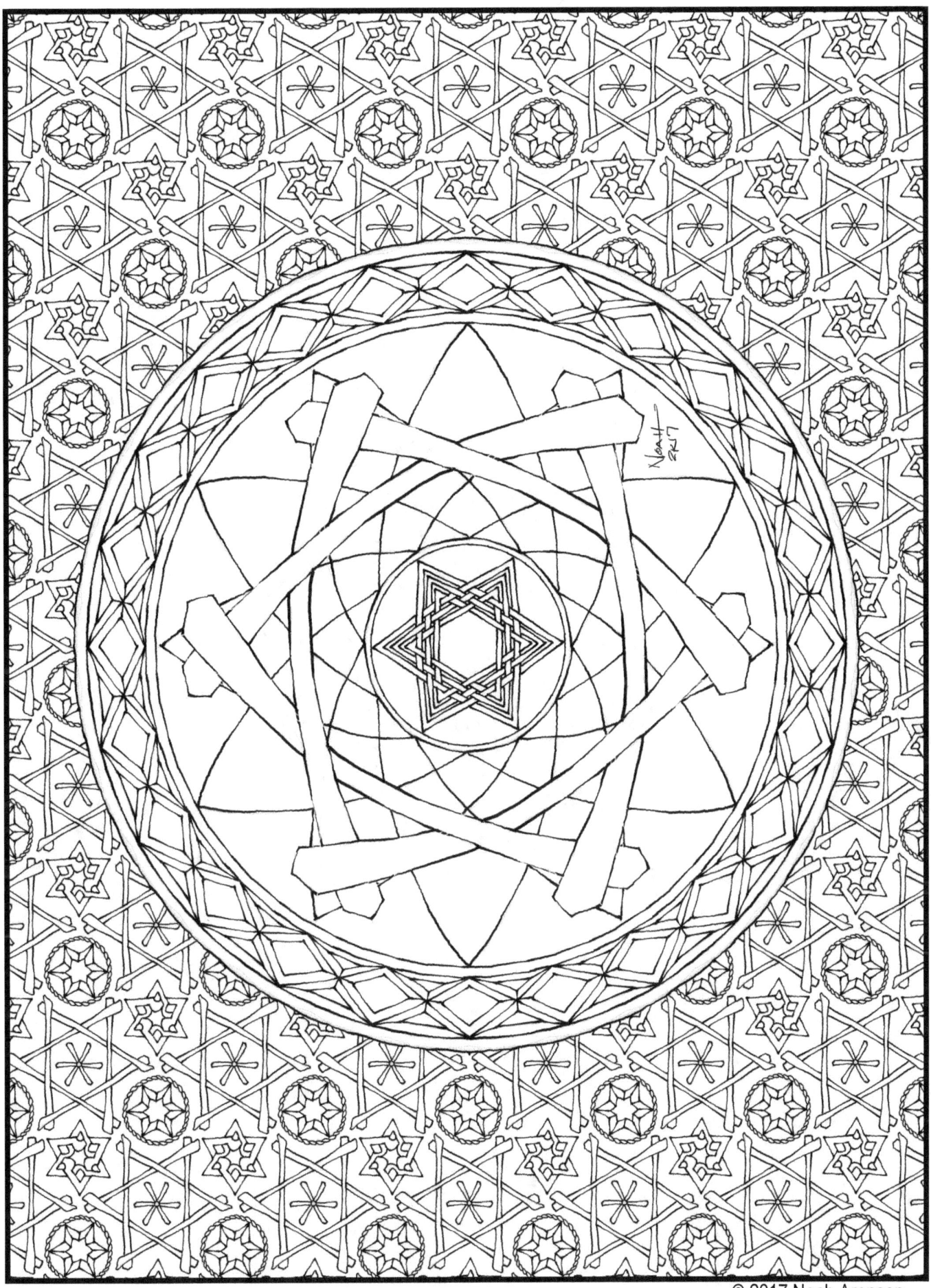

© 2017 Noah Aronson

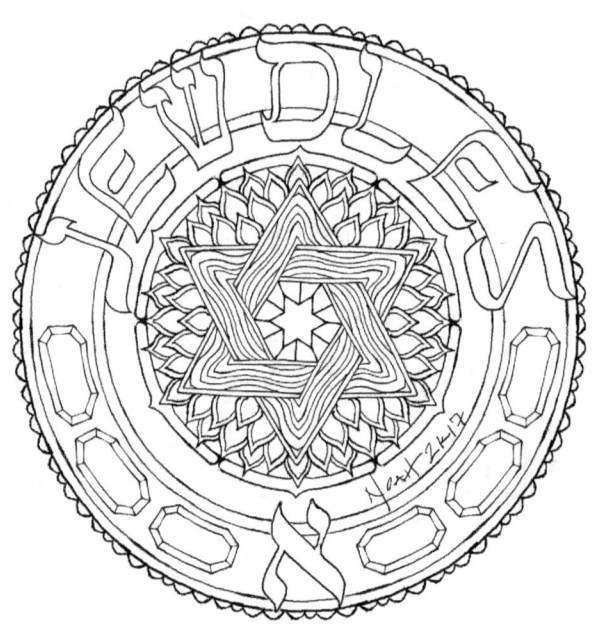

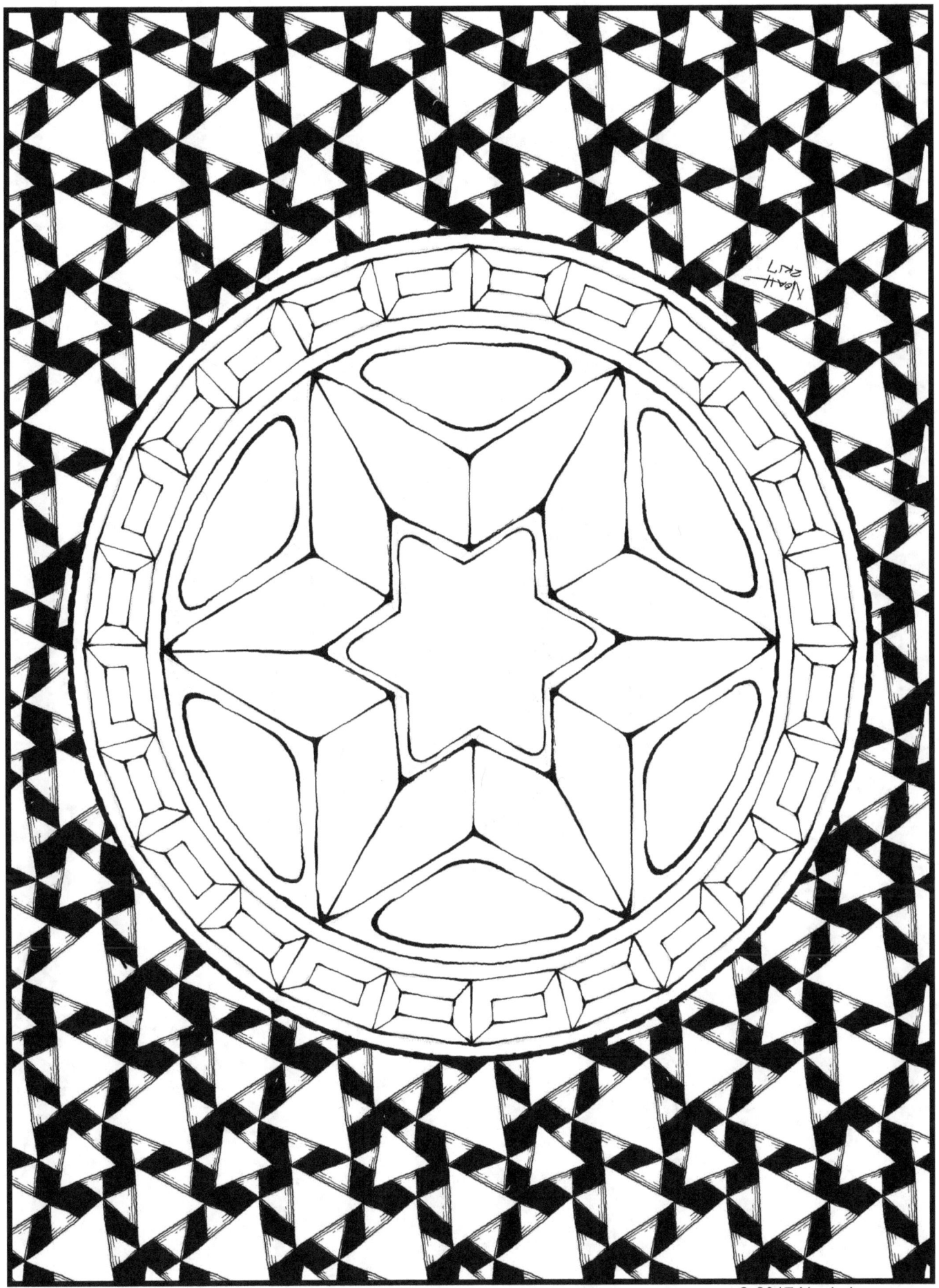

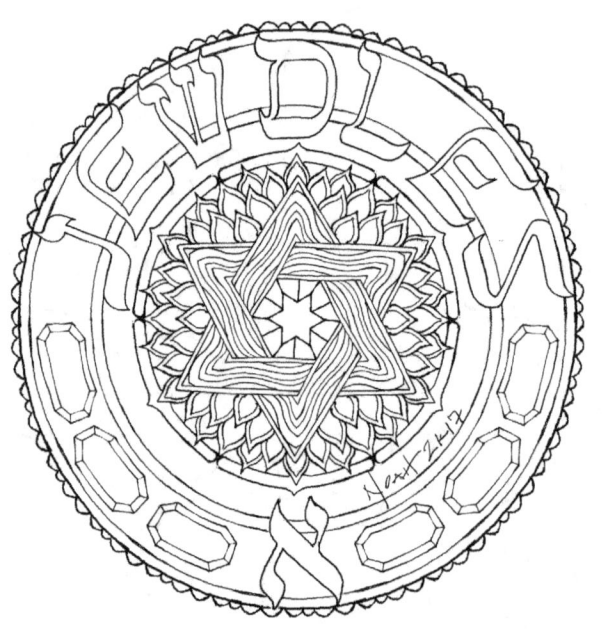

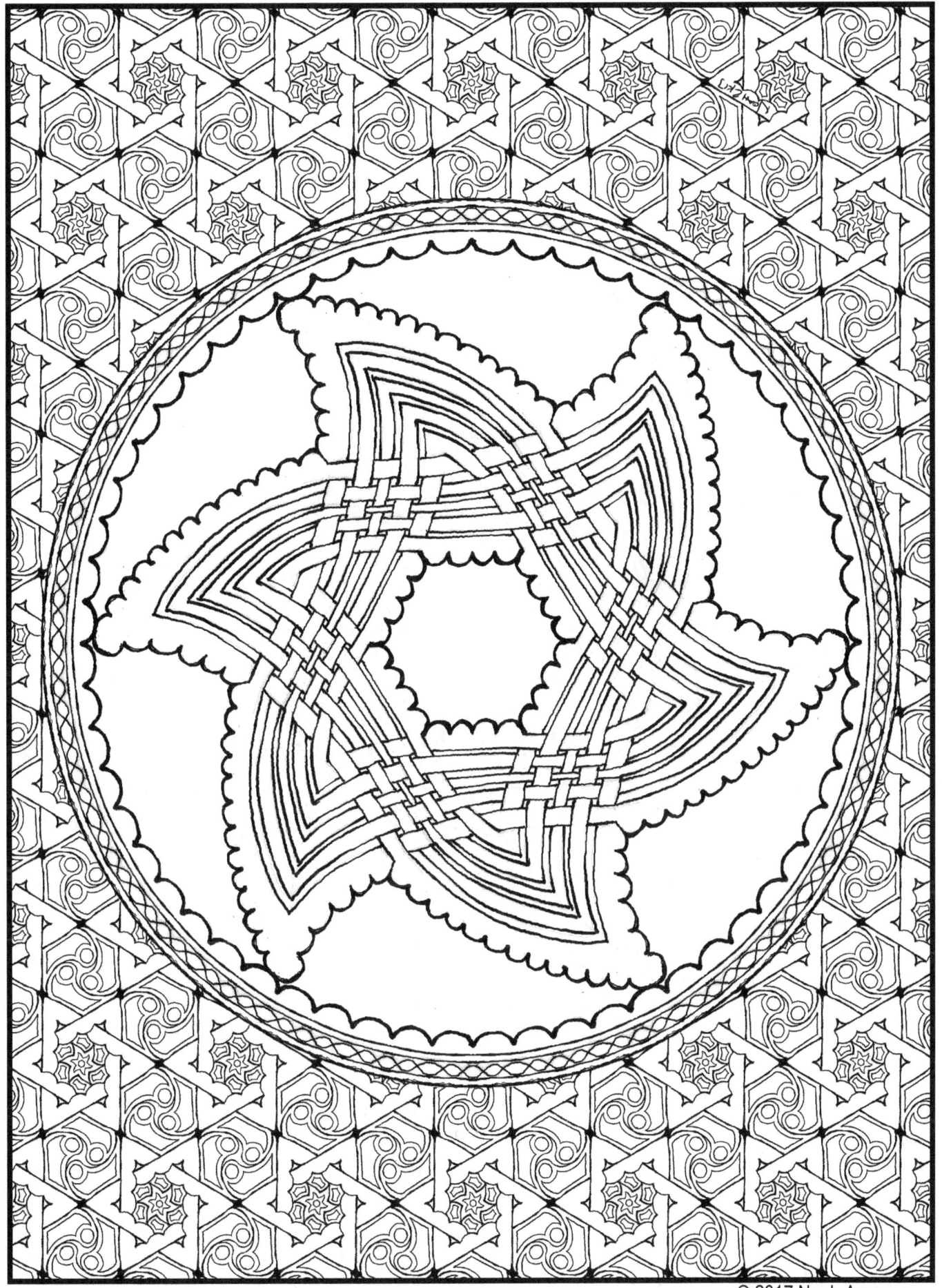

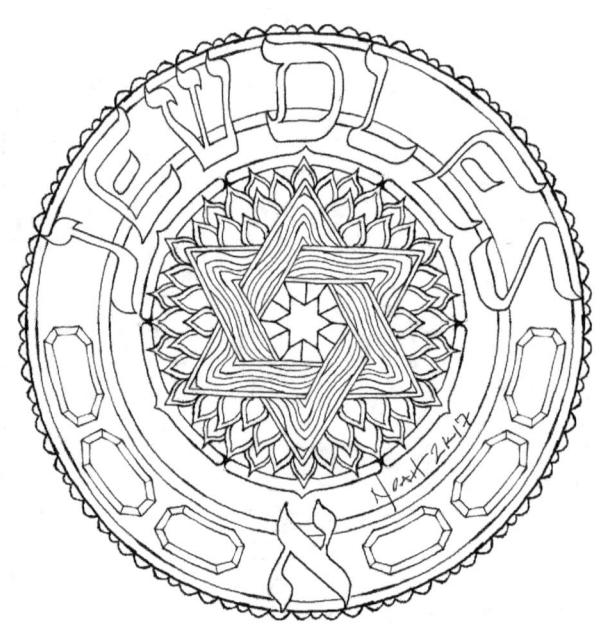

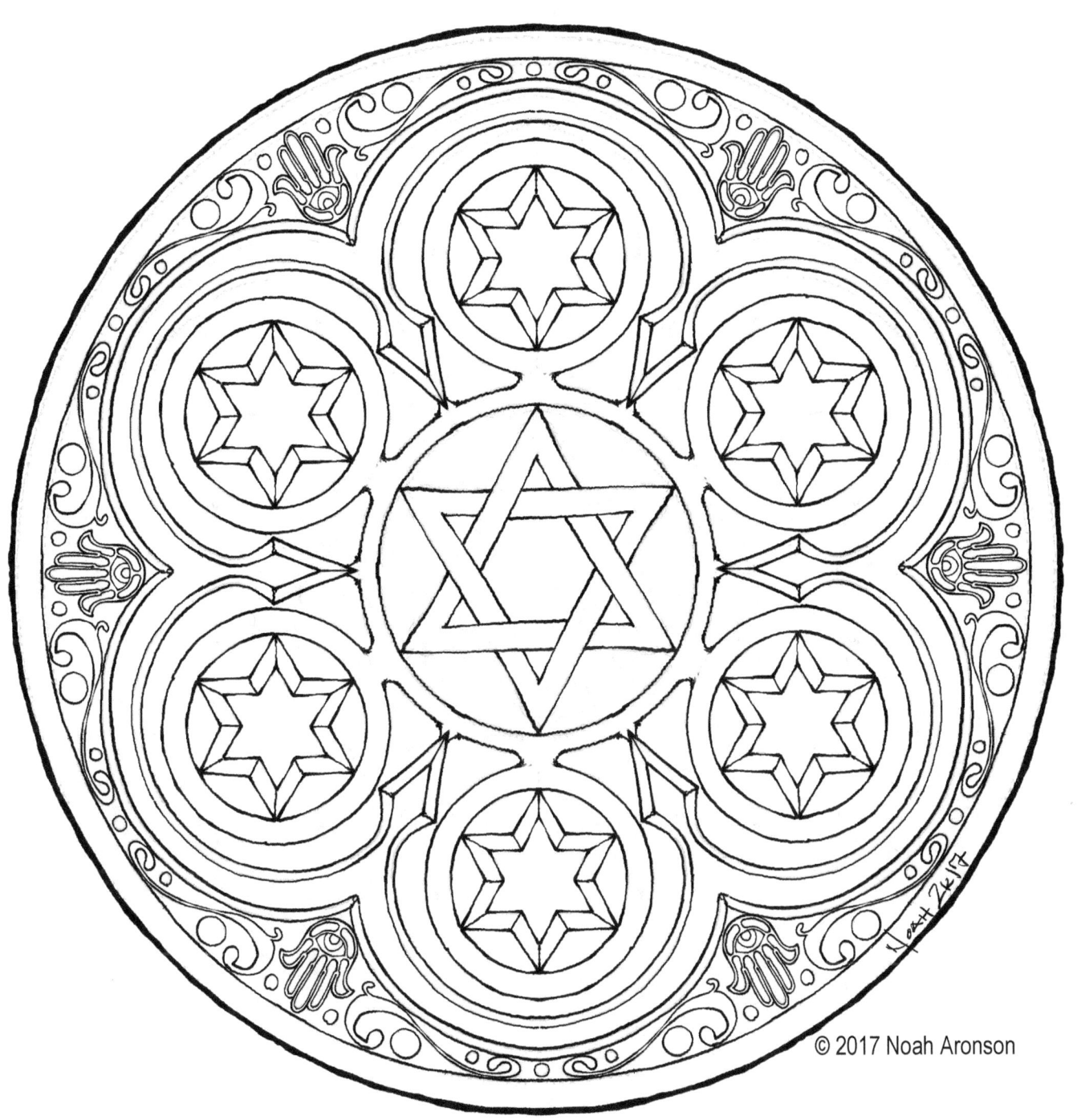

© 2017 Noah Aronson

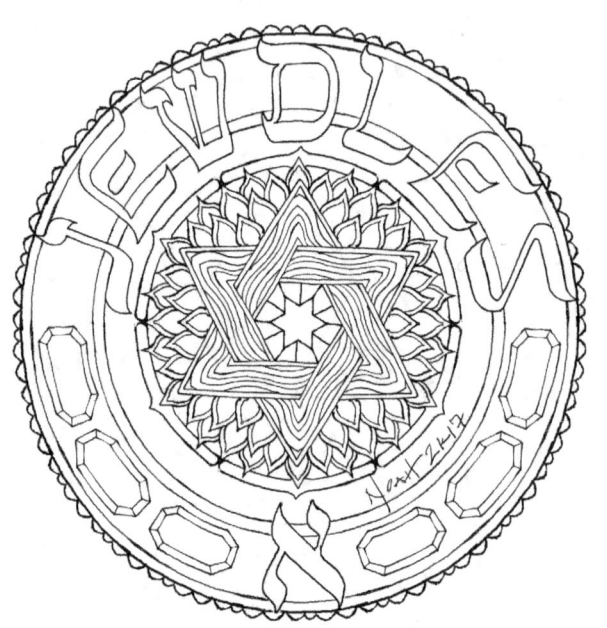

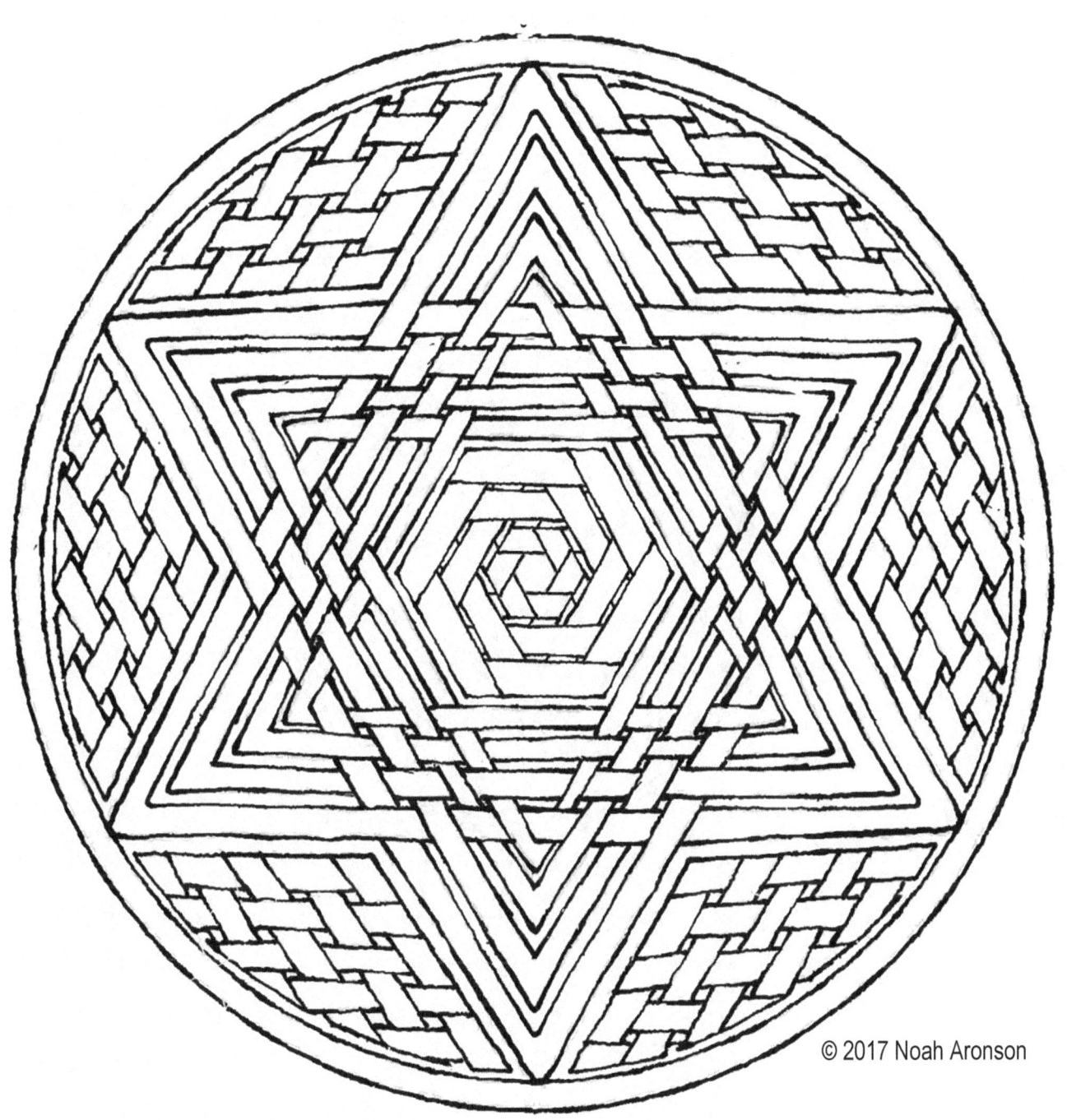

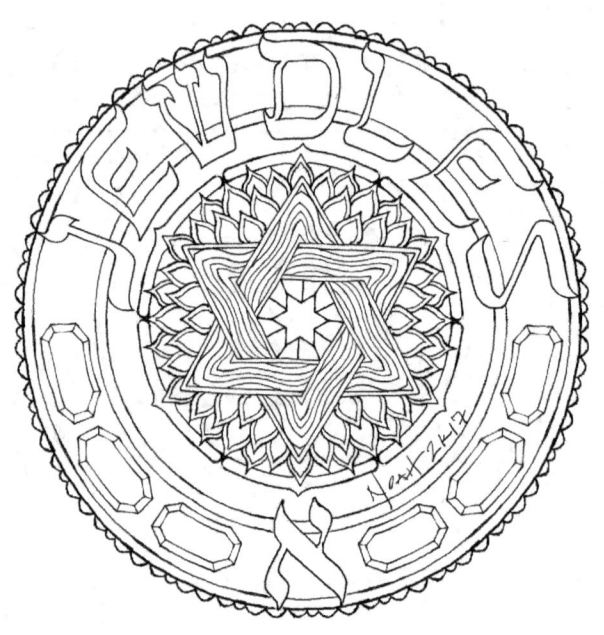

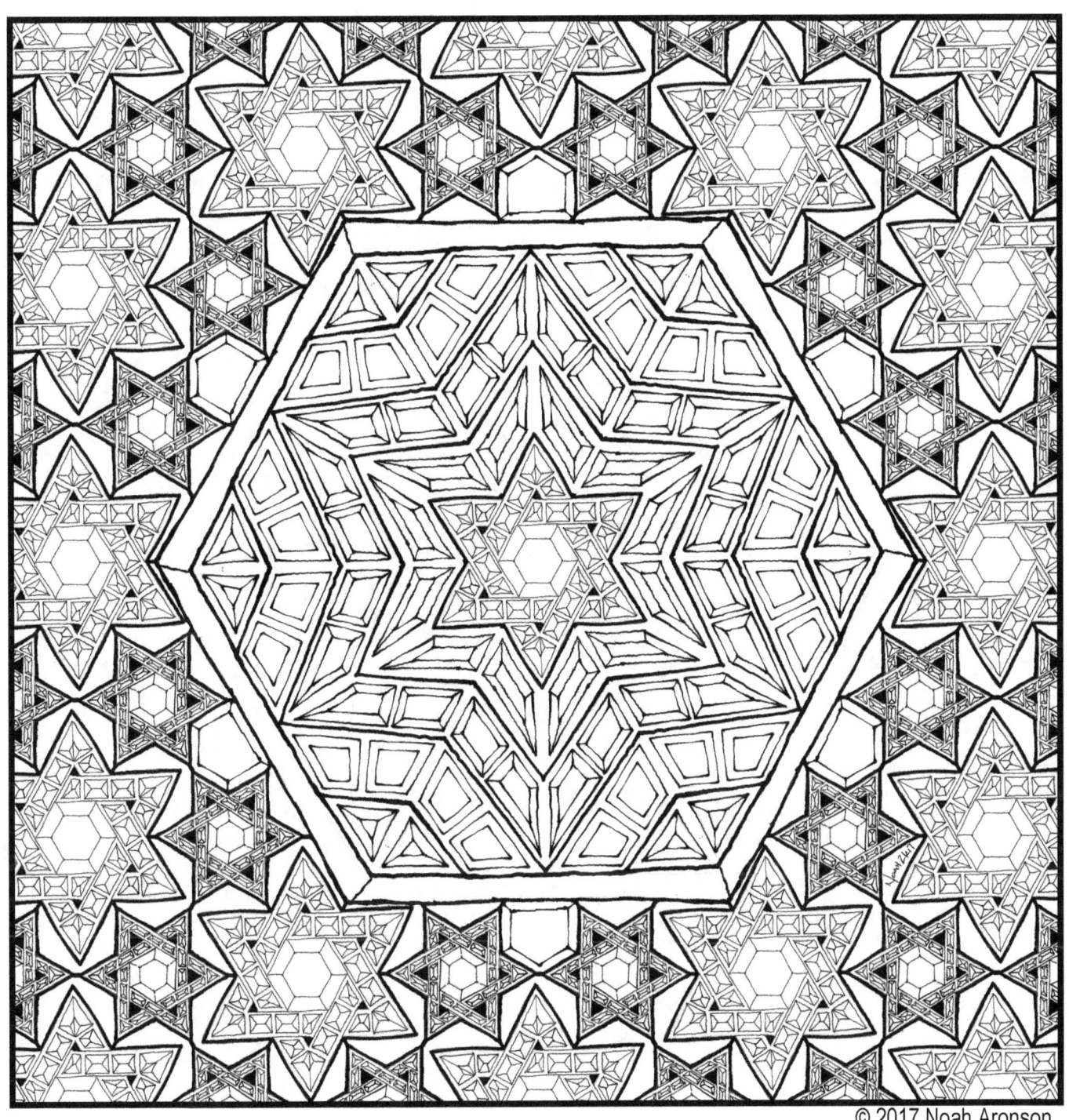

© 2017 Noah Aronson

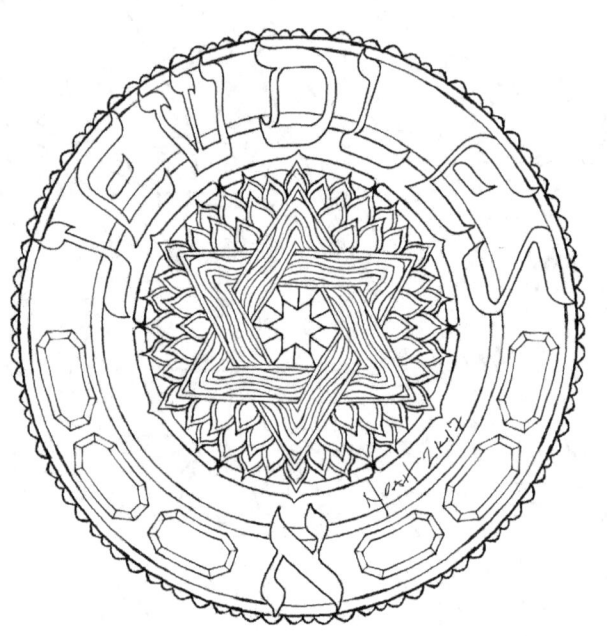

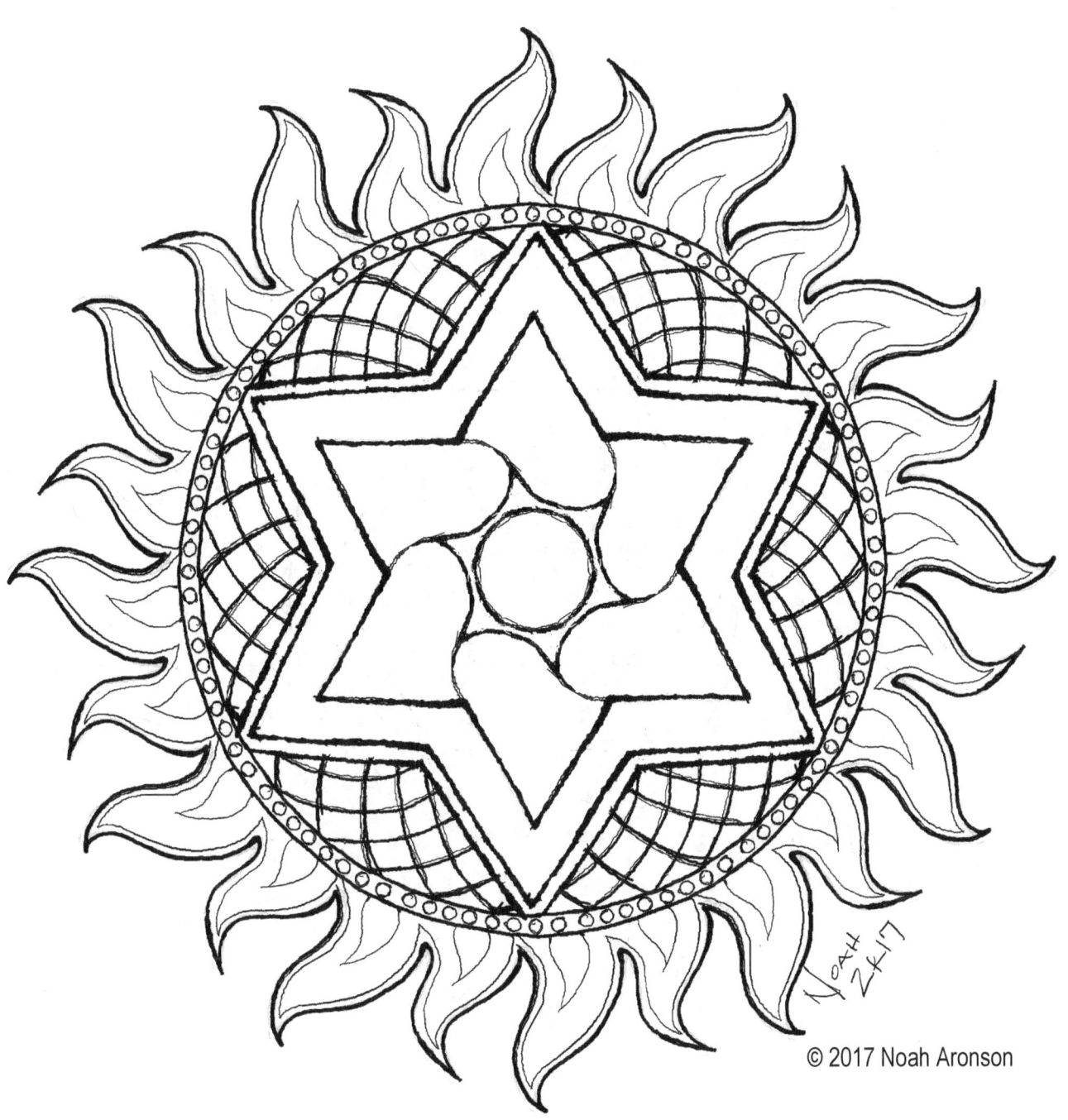

© 2017 Noah Aronson

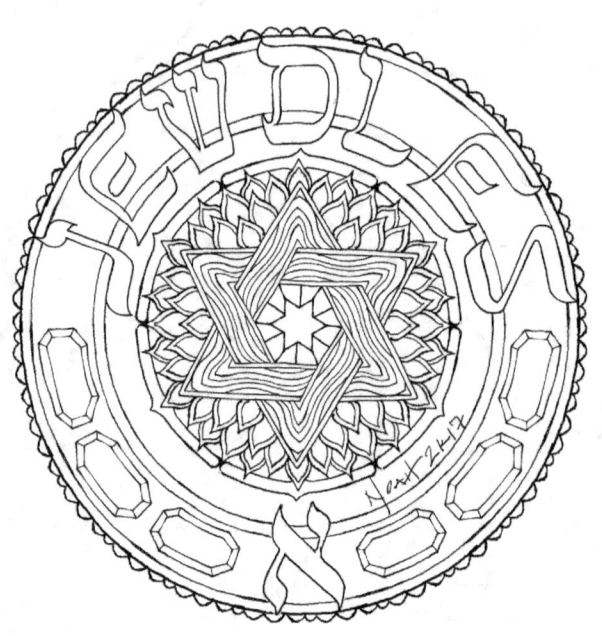

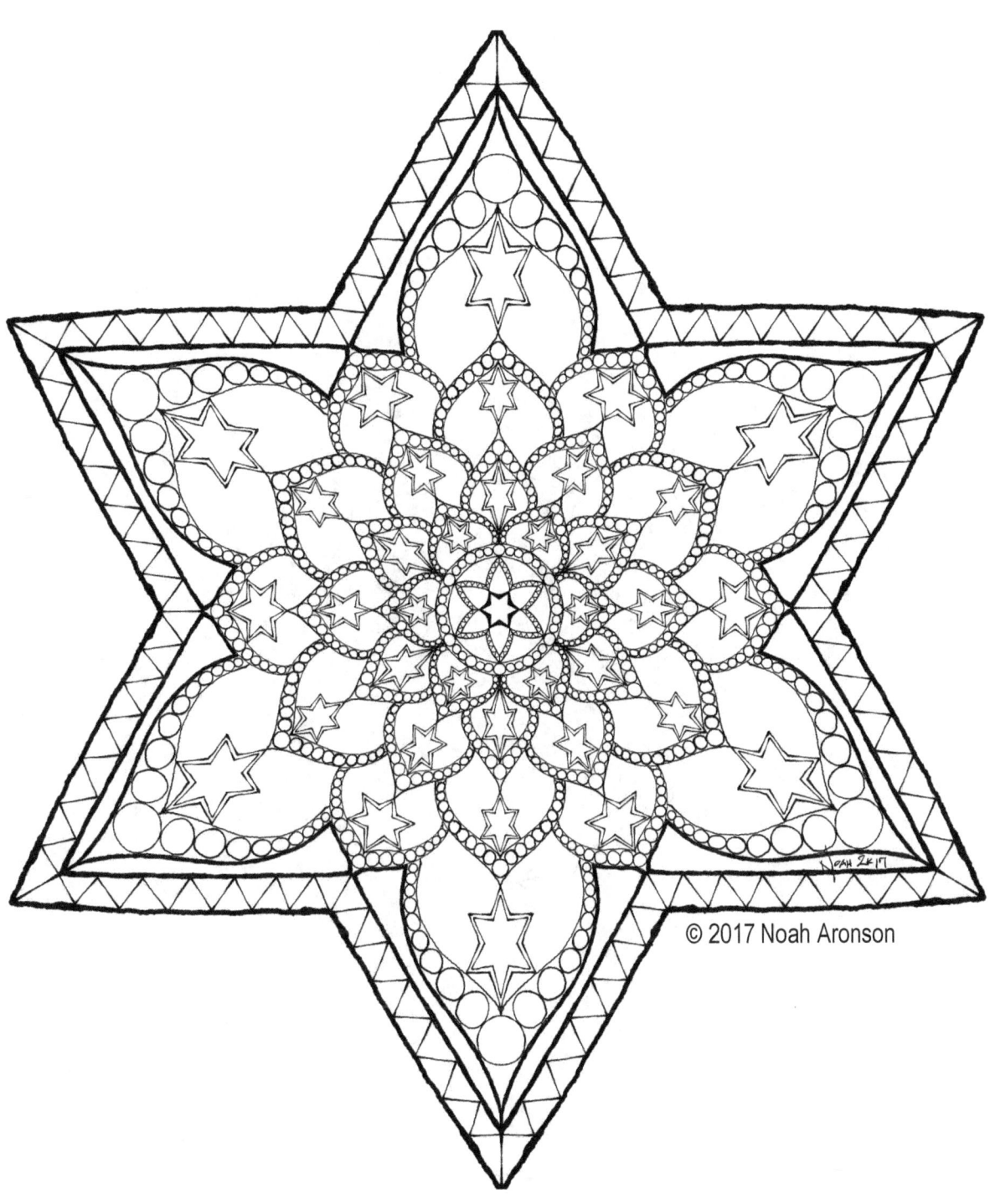

© 2017 Noah Aronson

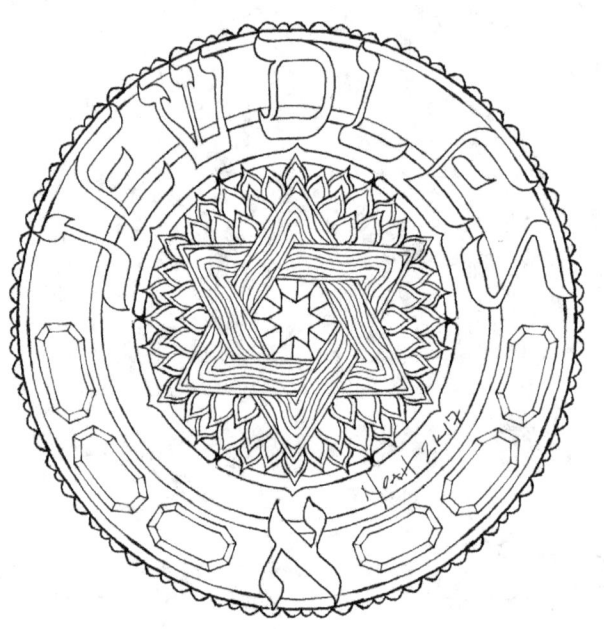

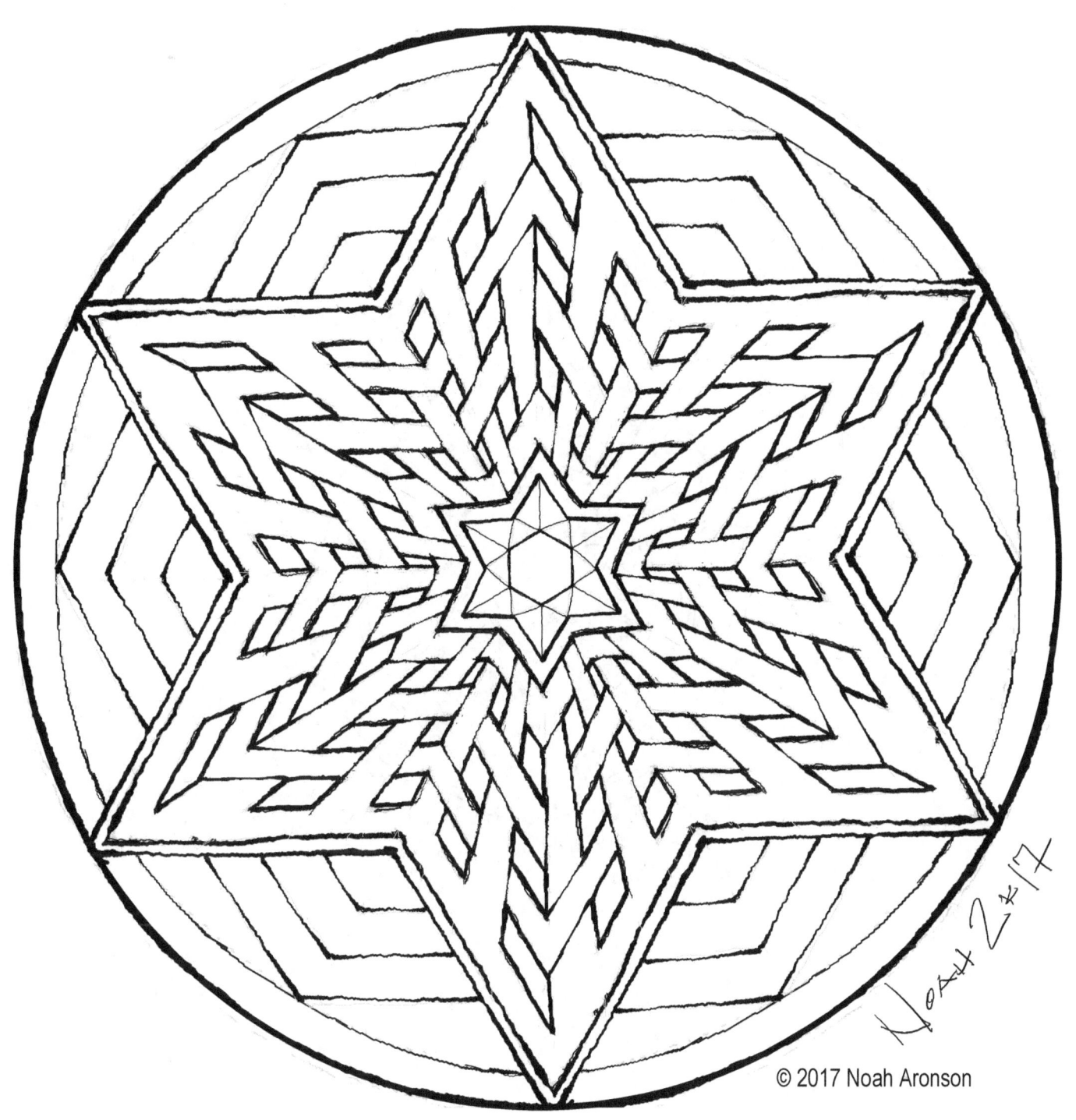

© 2017 Noah Aronson

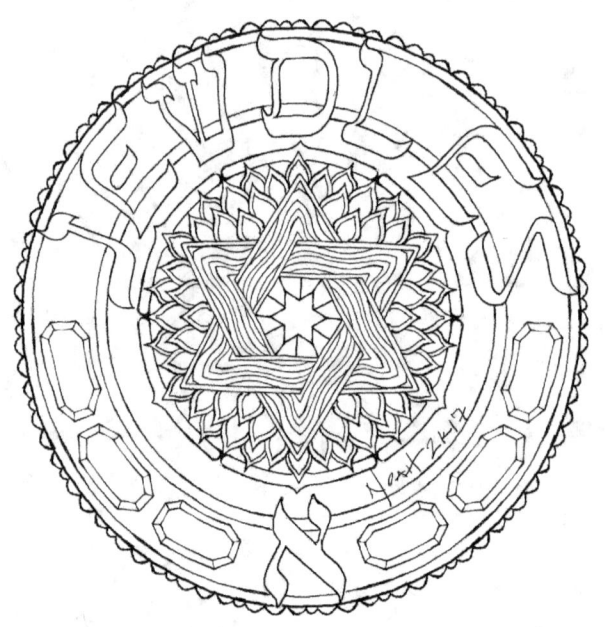

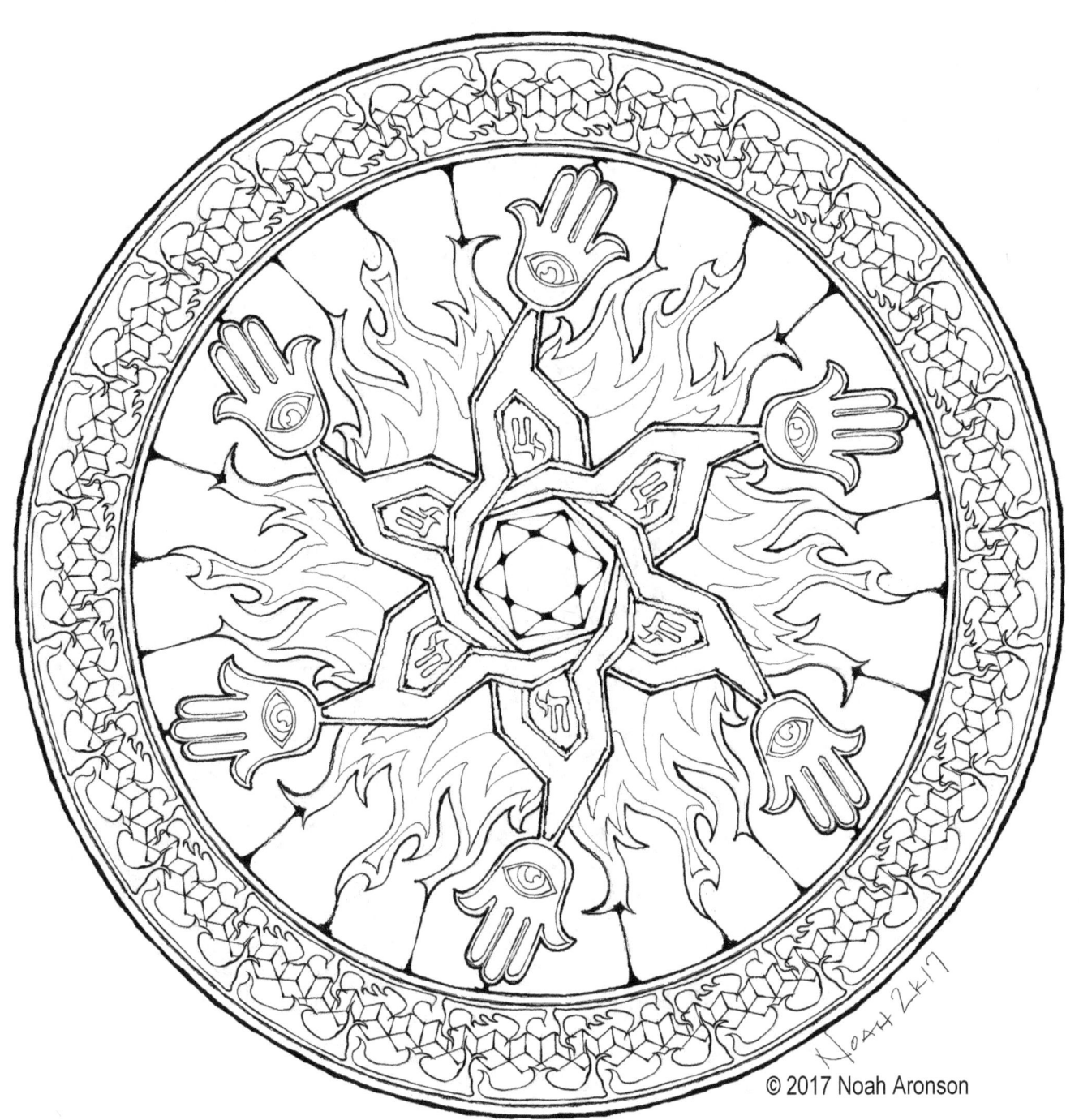

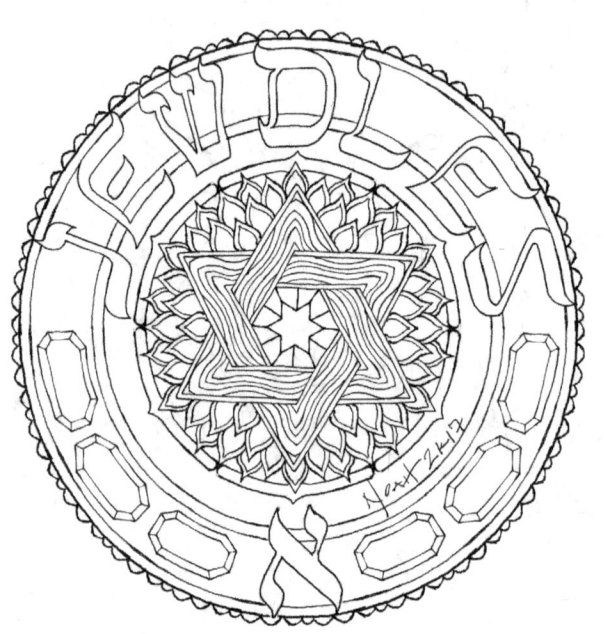

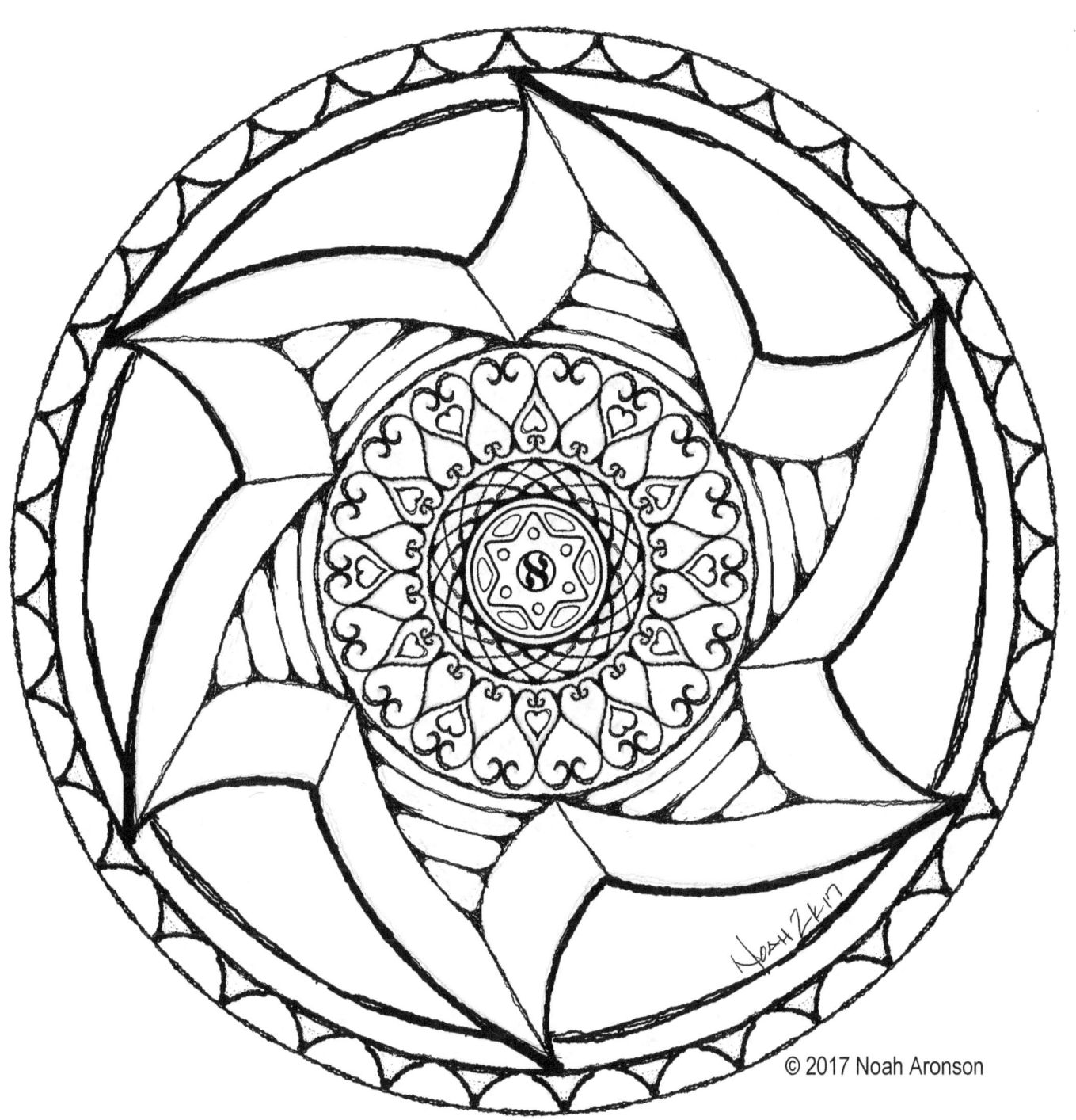

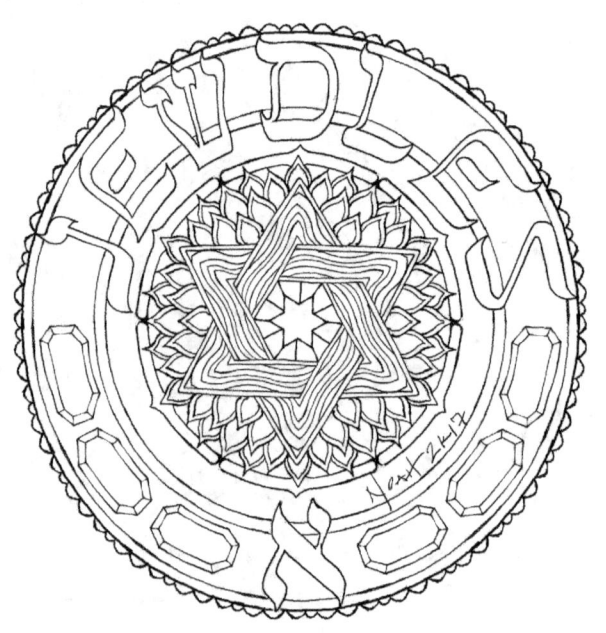

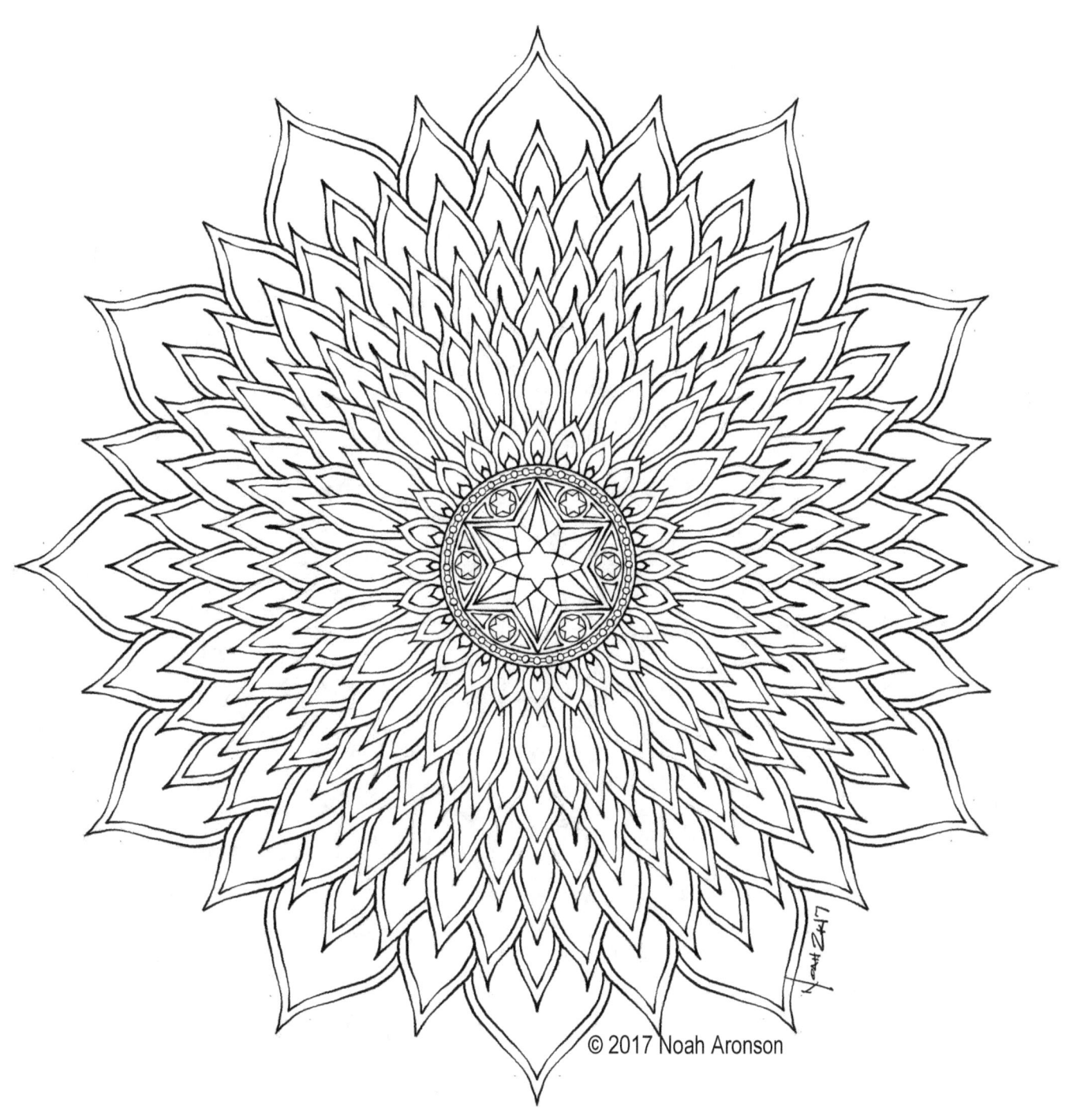
© 2017 Noah Aronson

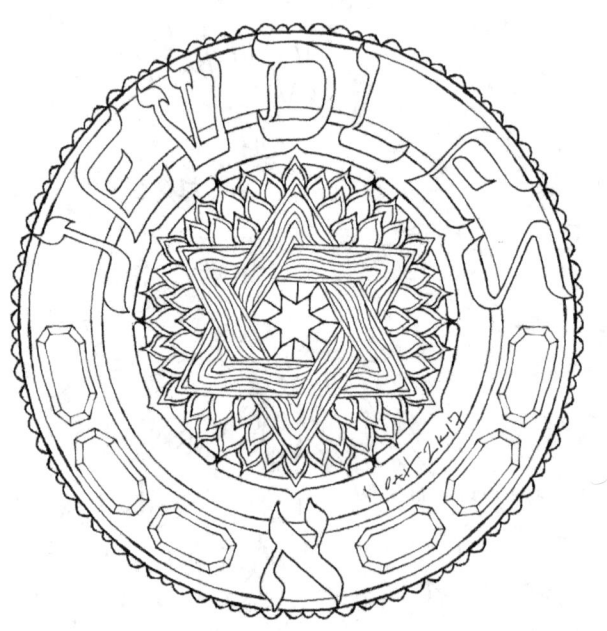

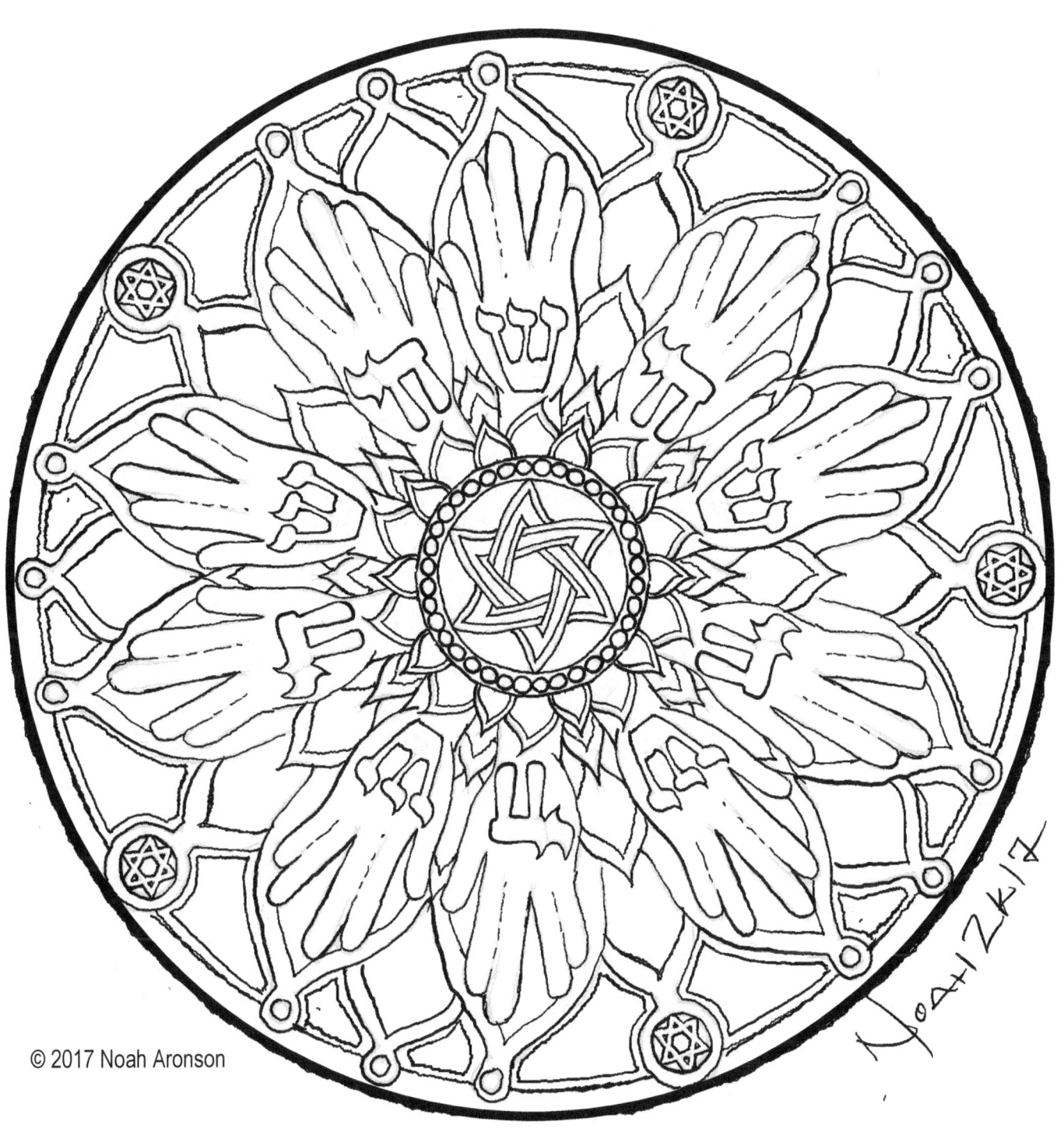

© 2017 Noah Aronson

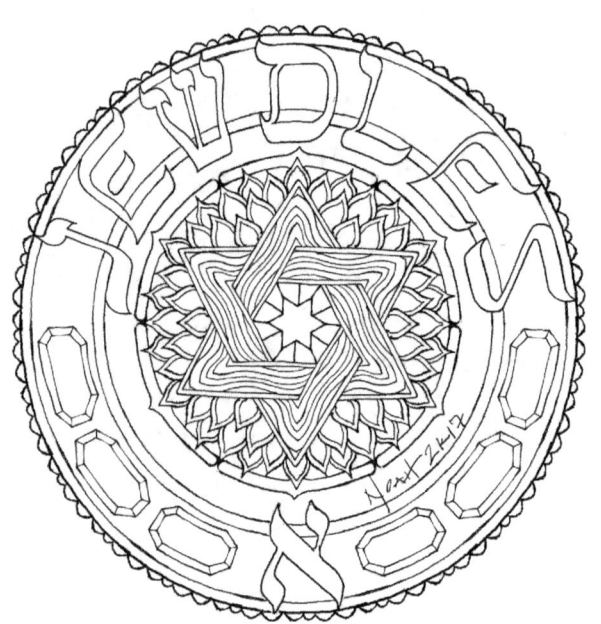

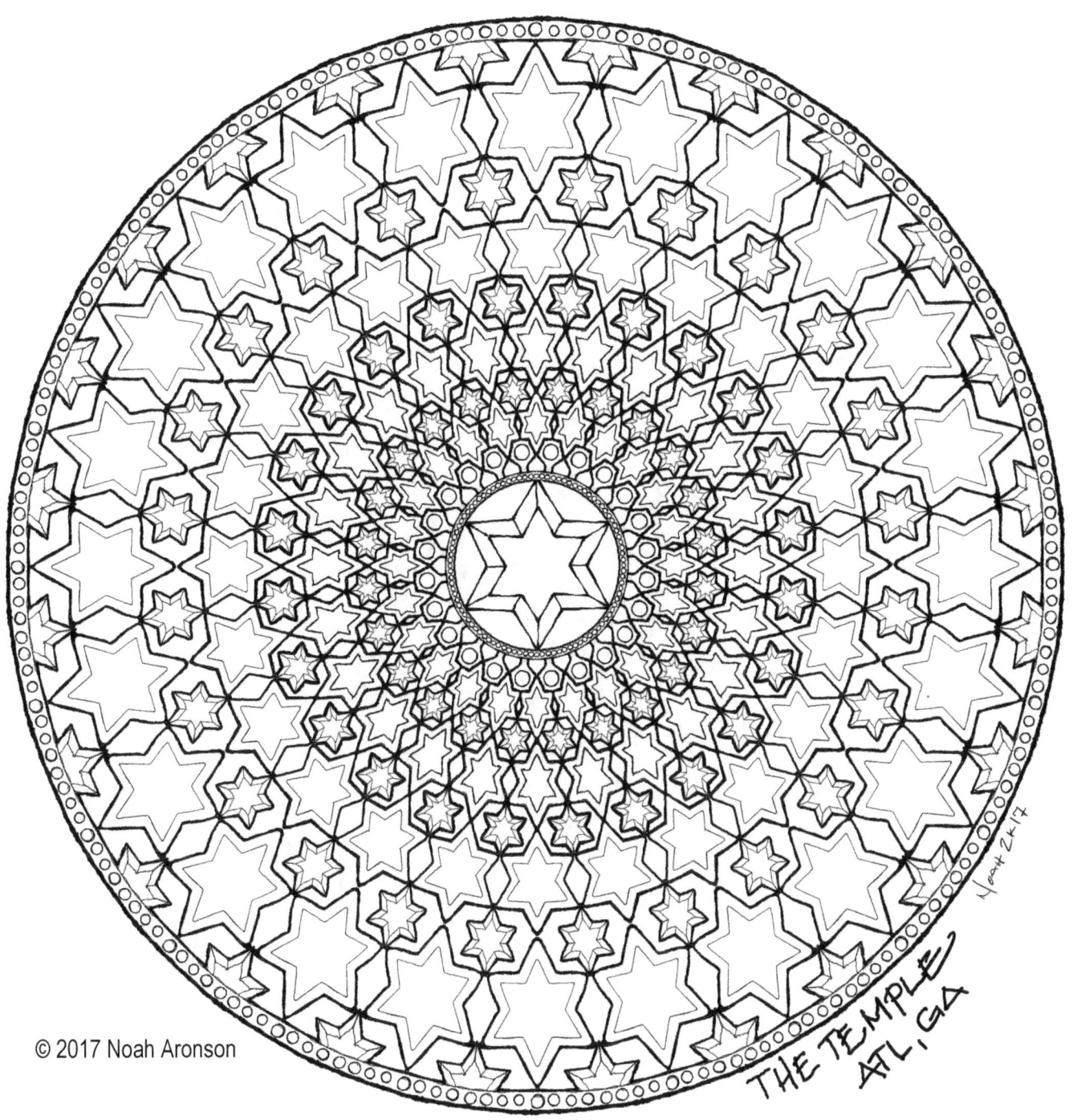

© 2017 Noah Aronson

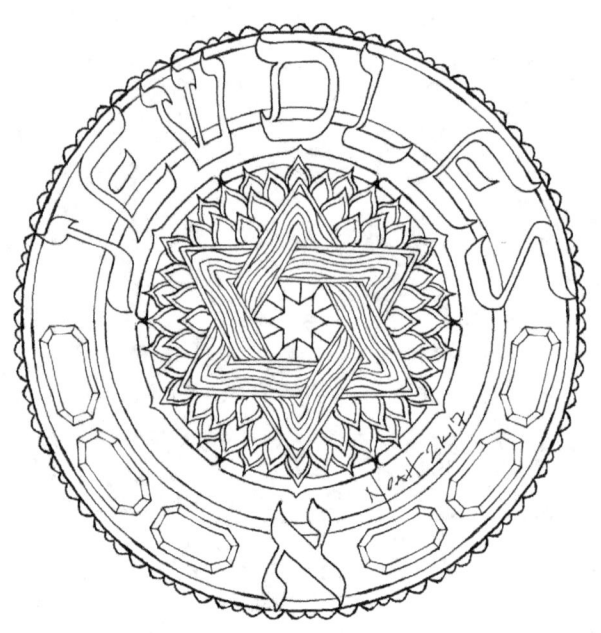

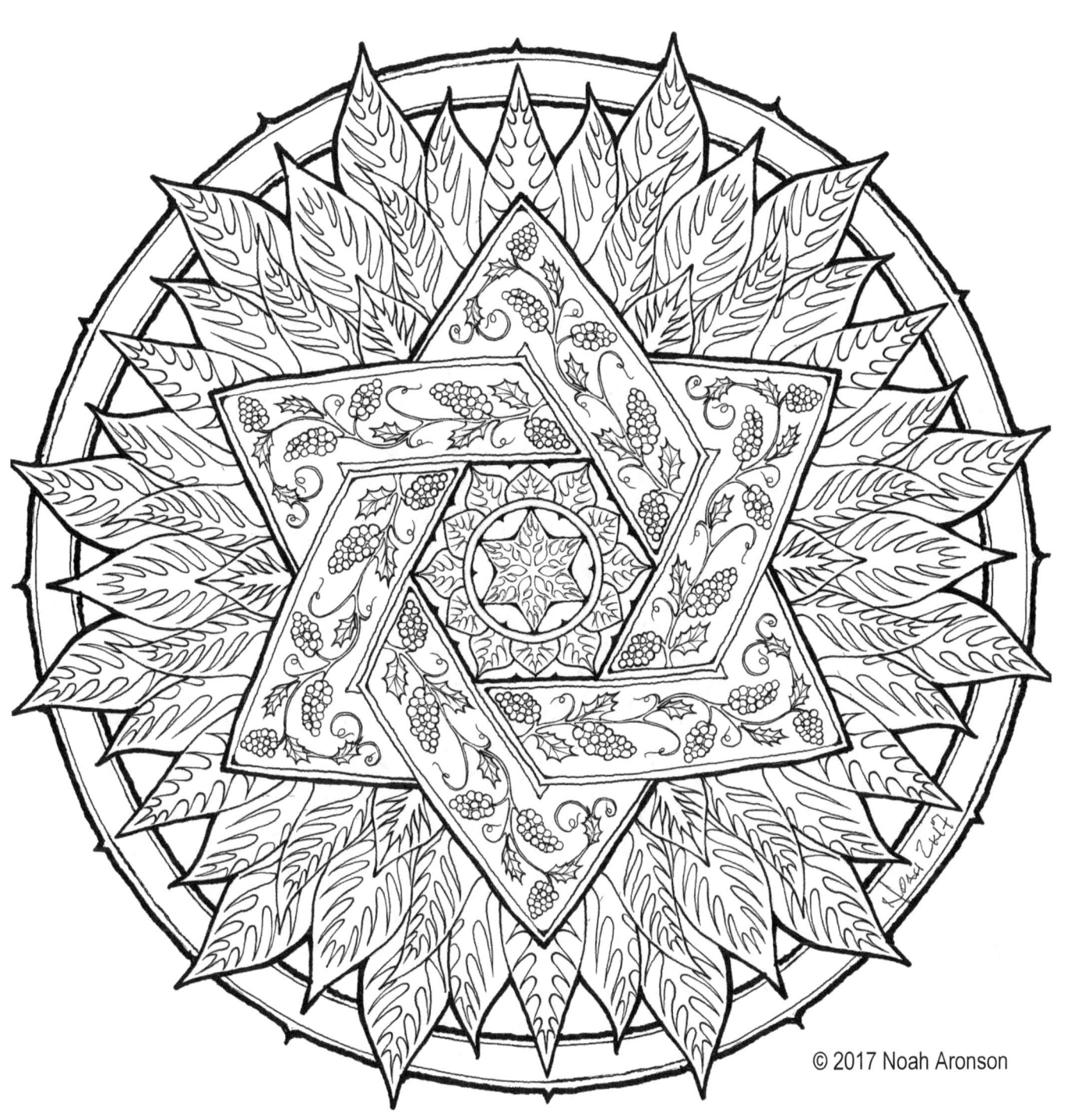

© 2017 Noah Aronson

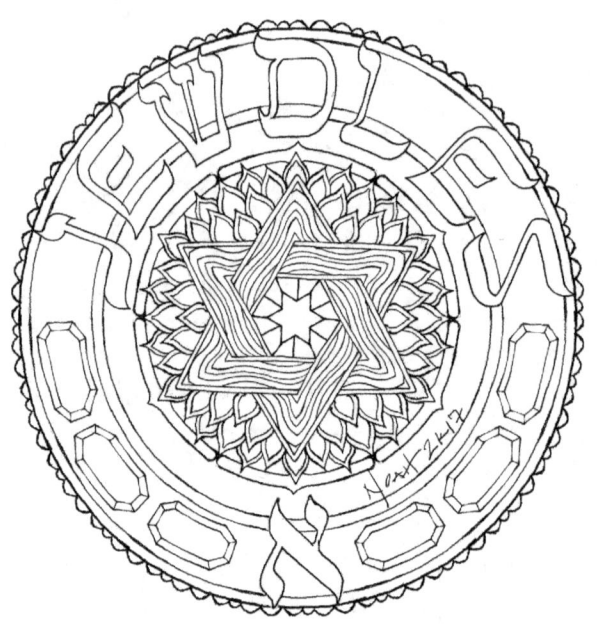

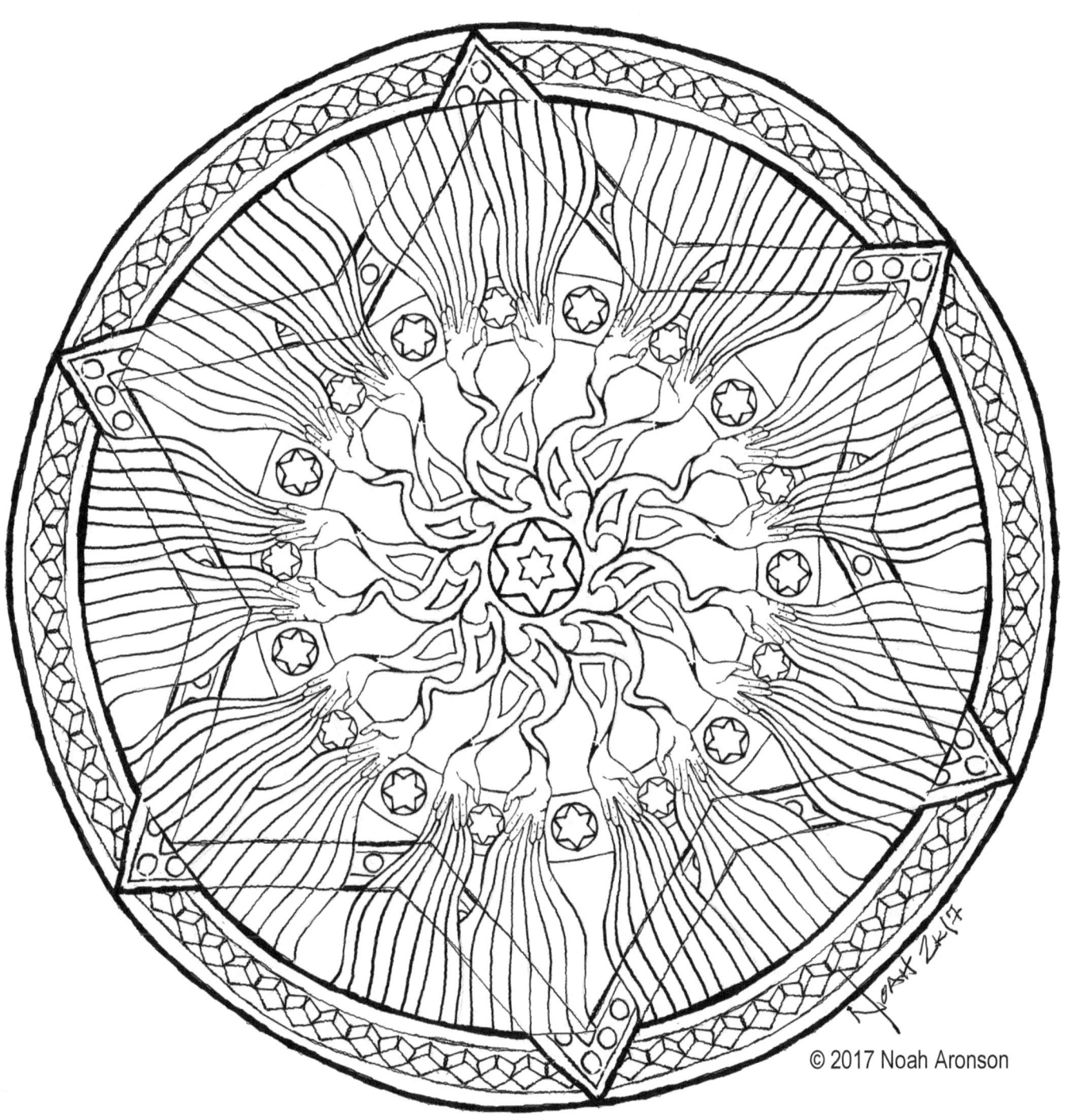

© 2017 Noah Aronson

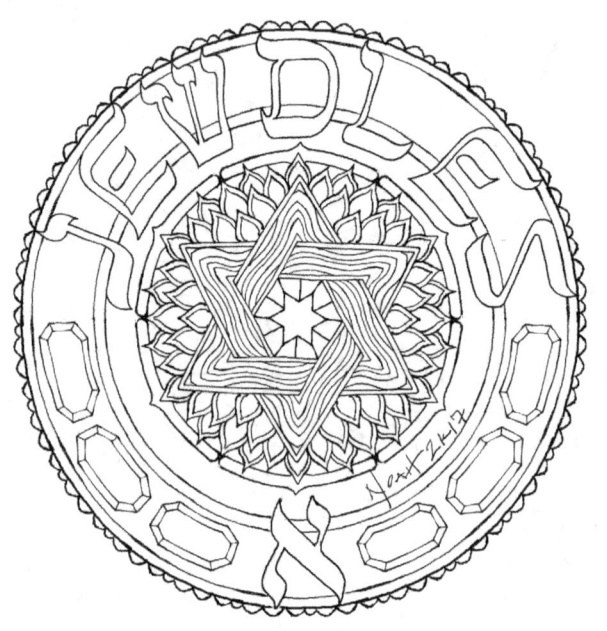

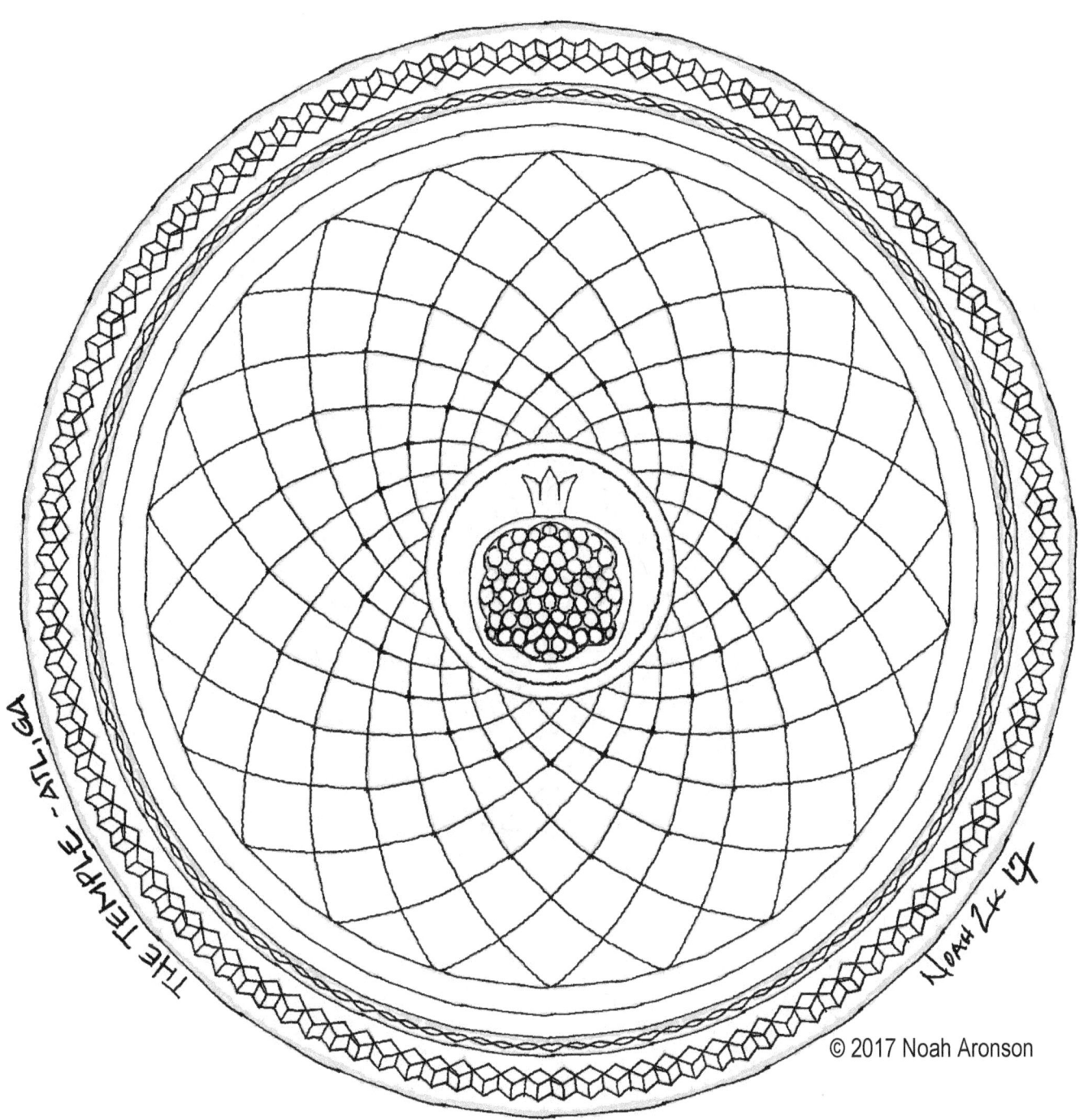

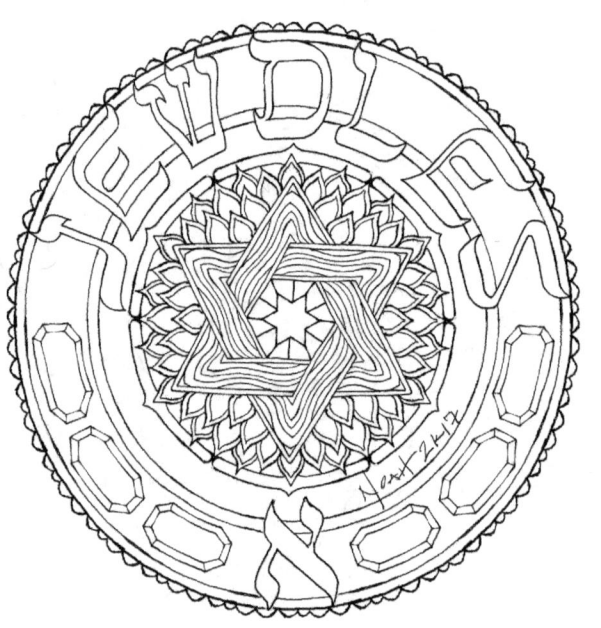

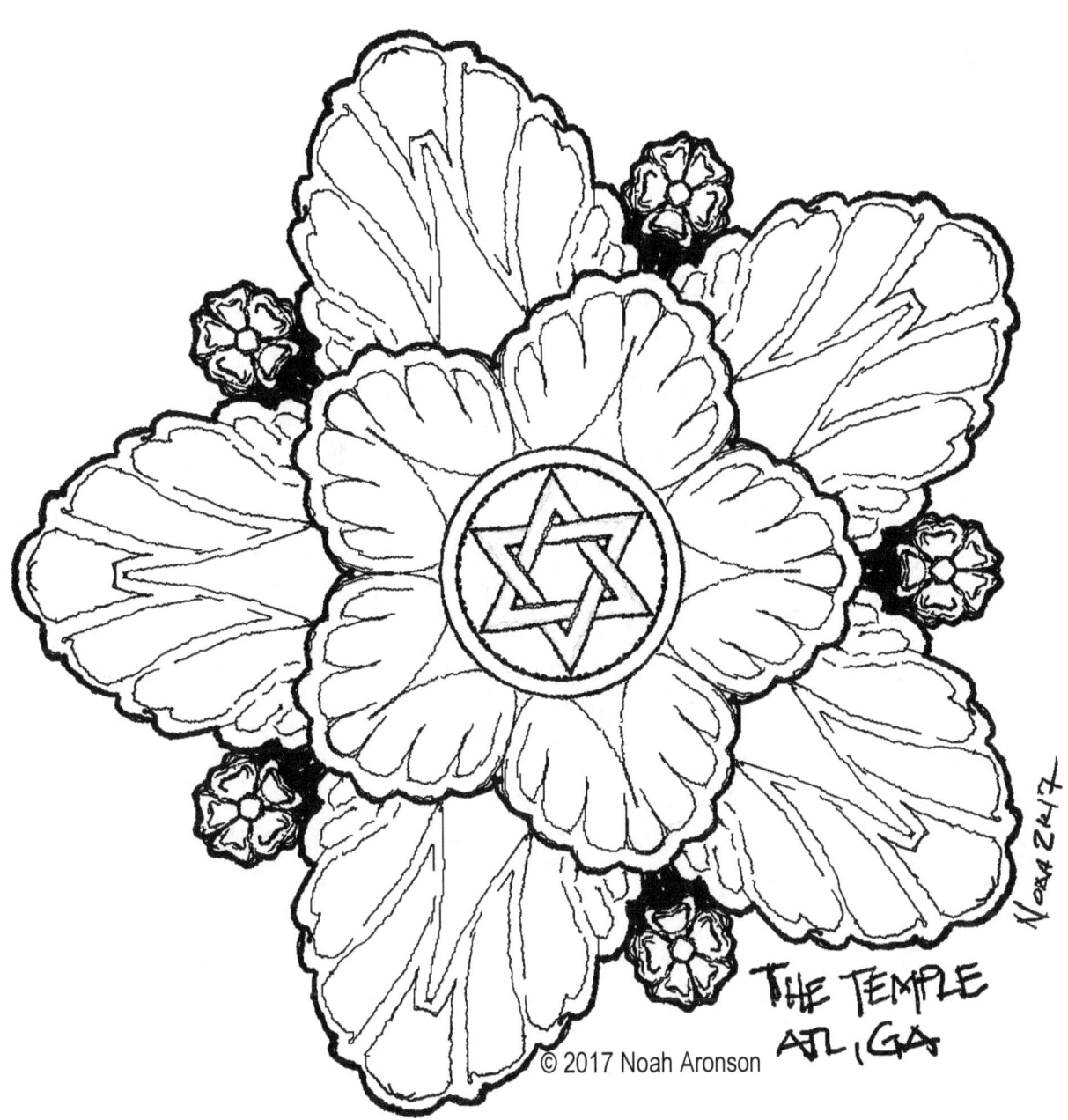

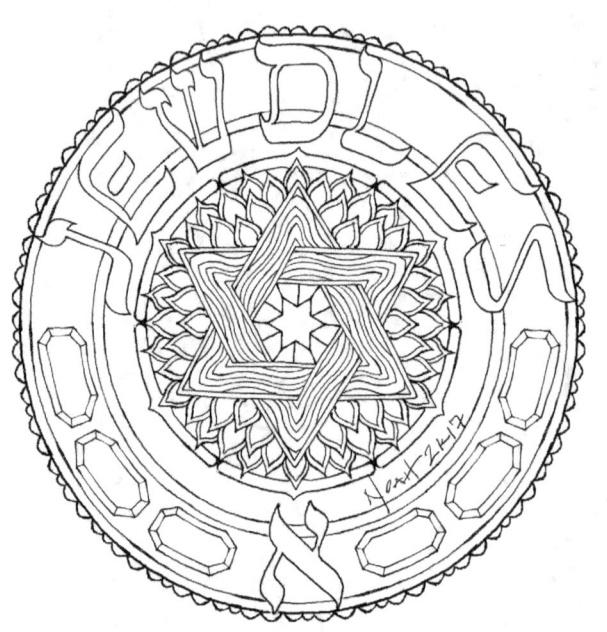

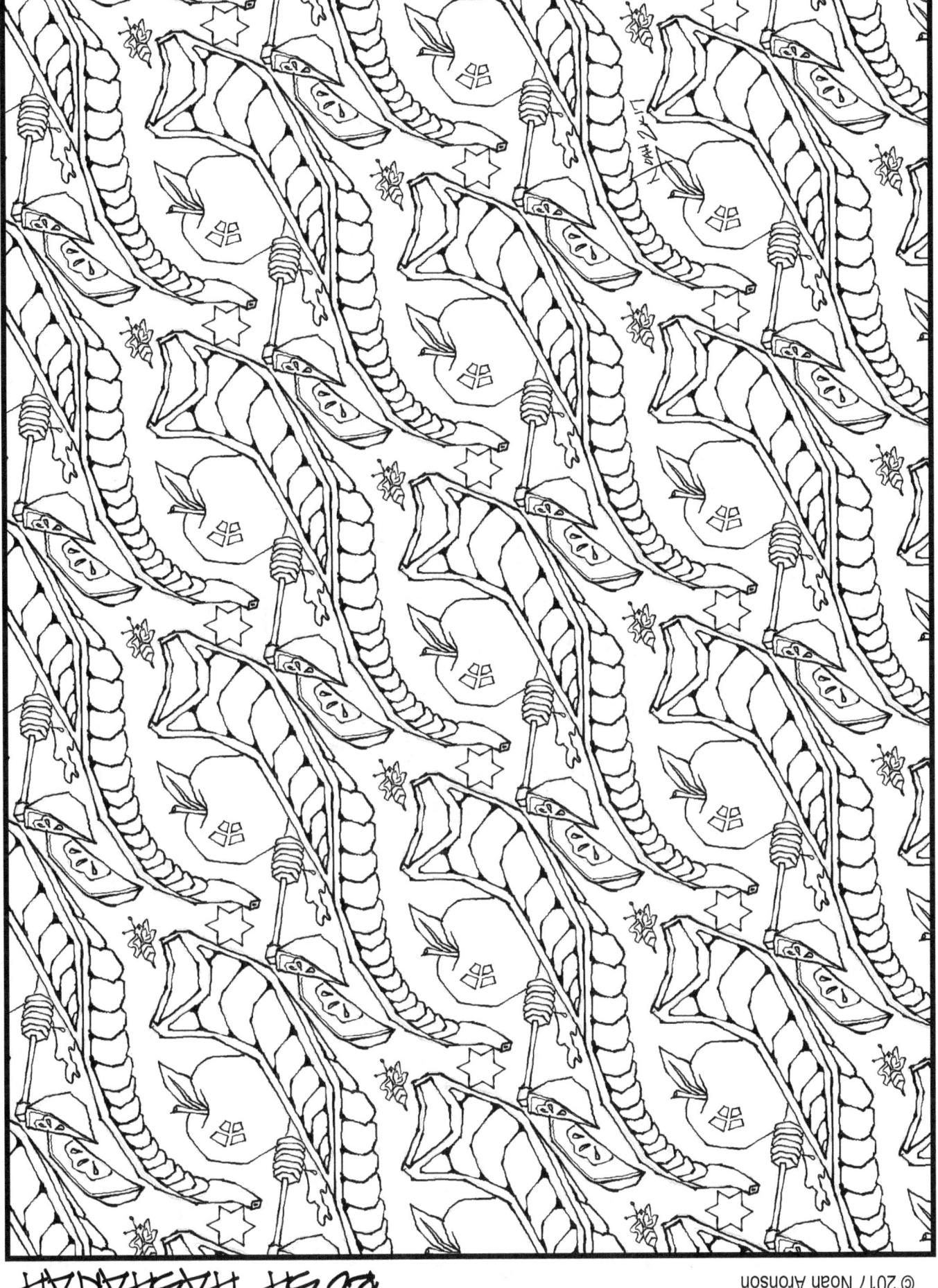

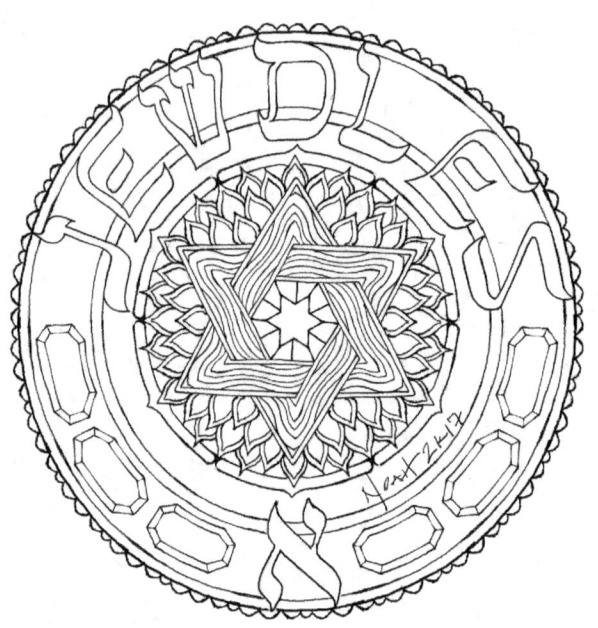

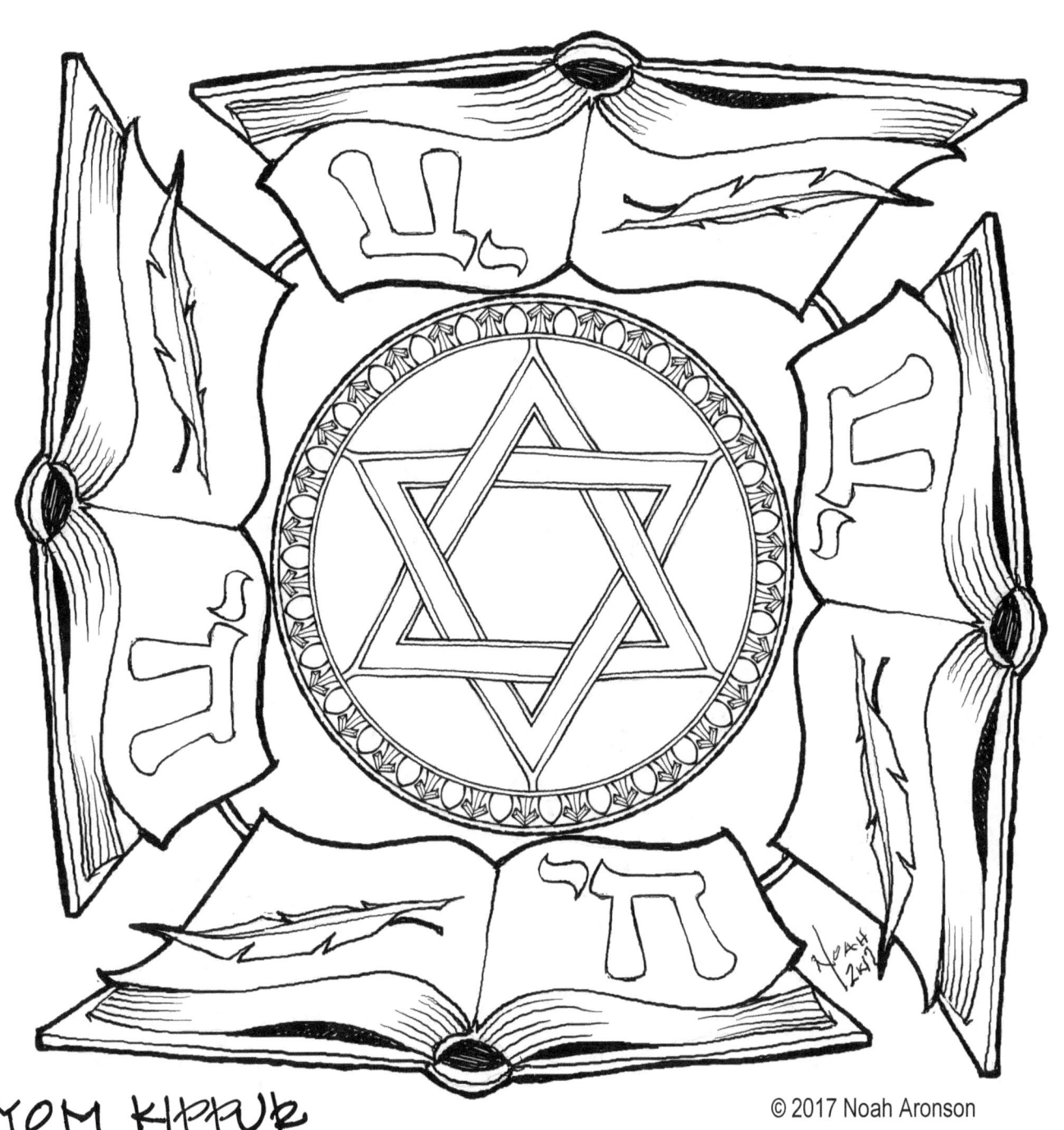

YOM KIPPUR

© 2017 Noah Aronson

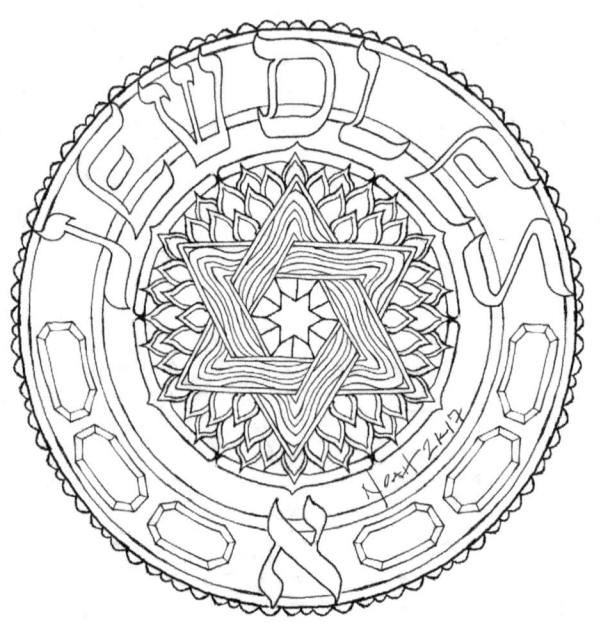

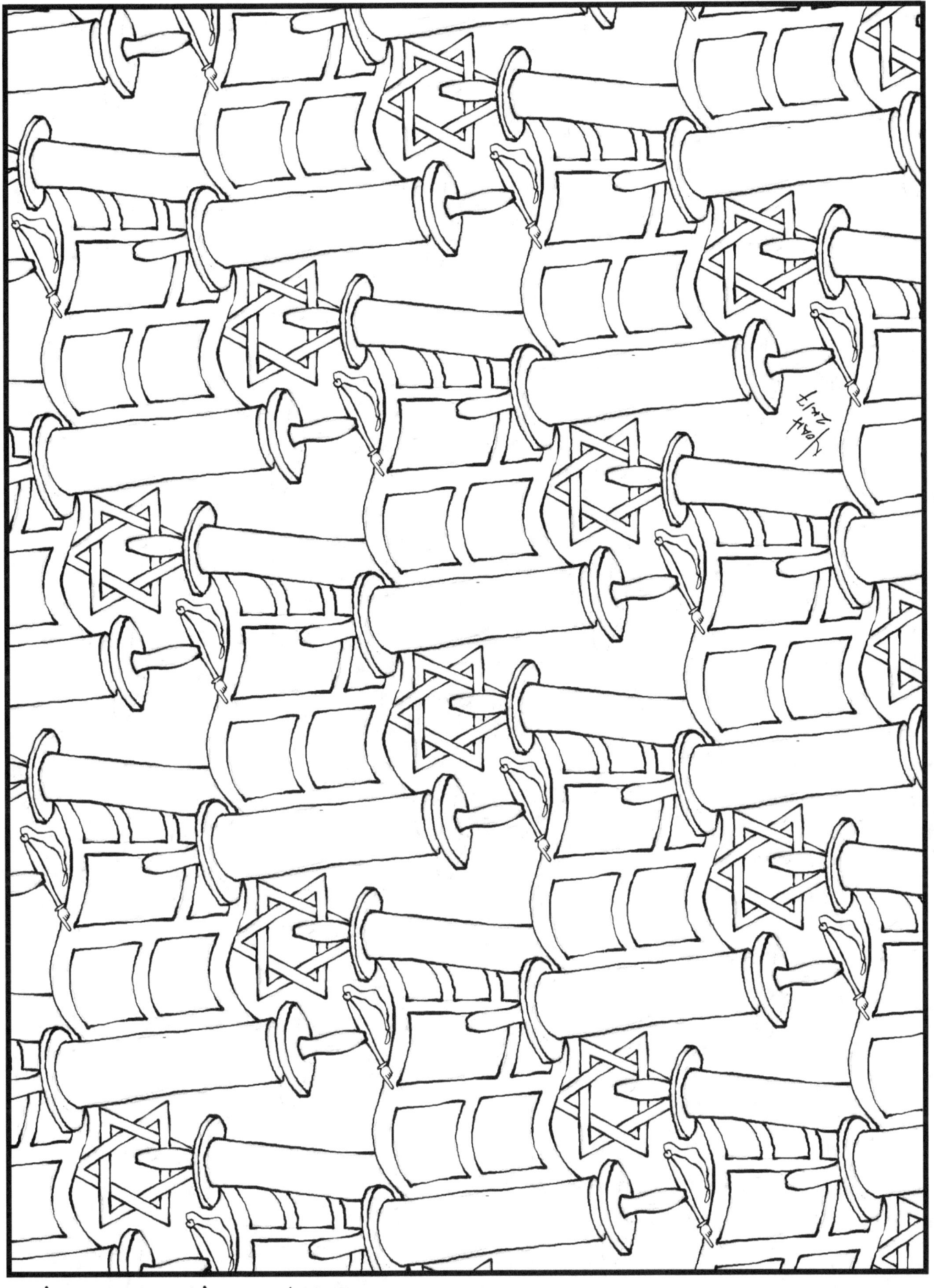

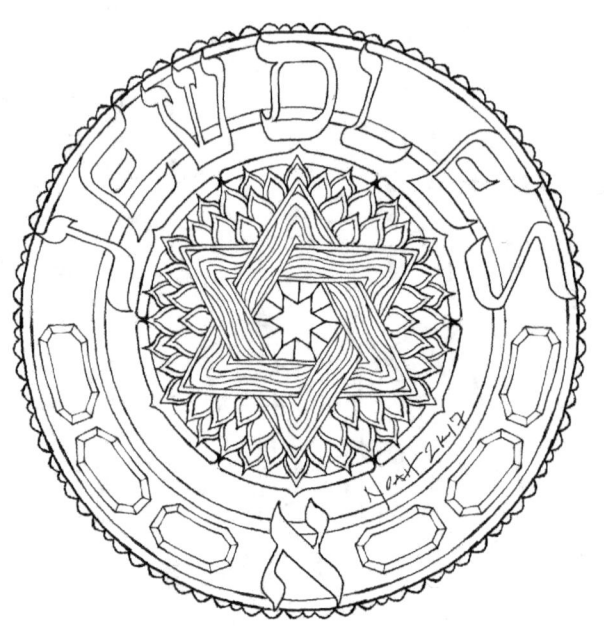

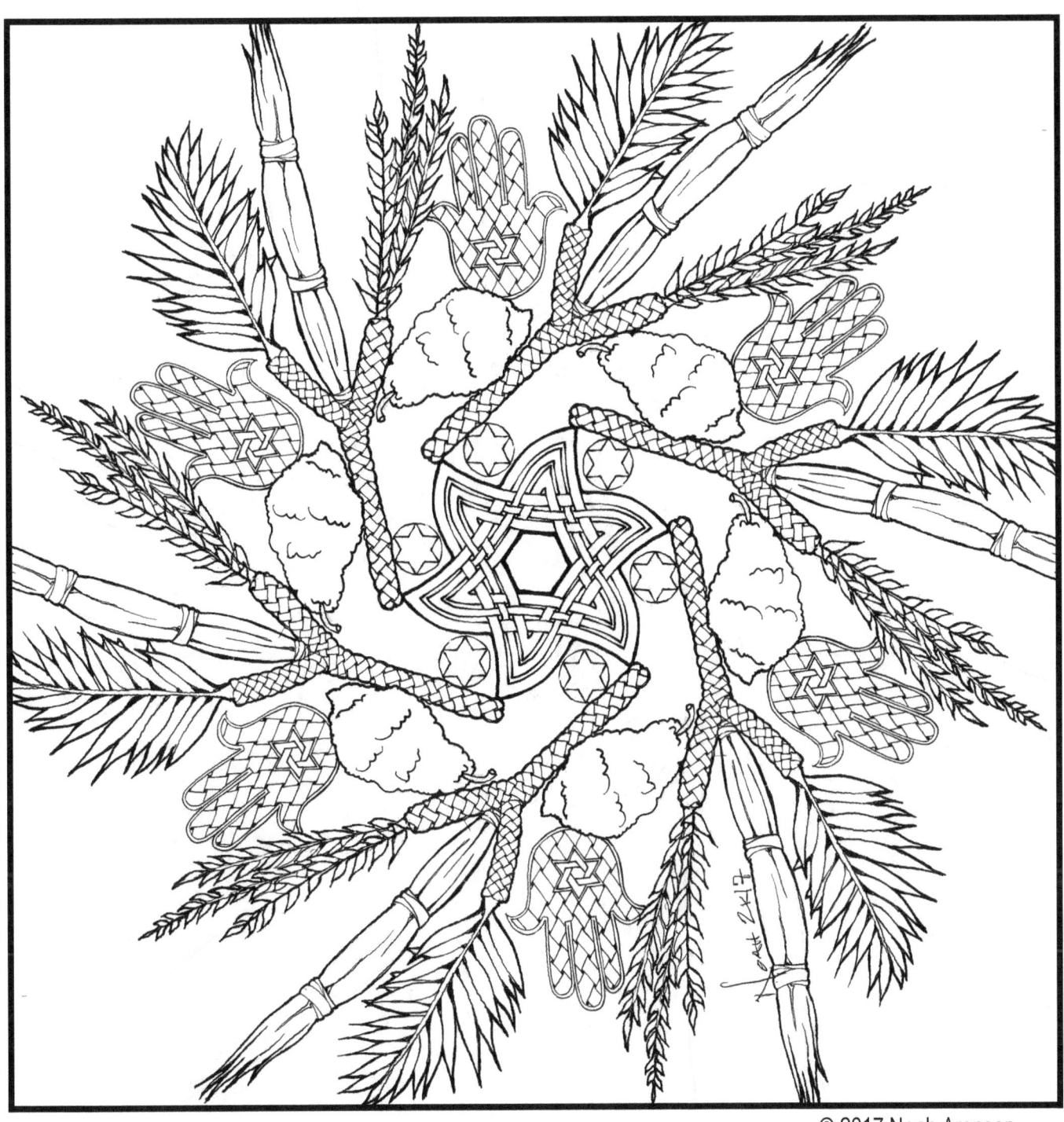

SUKKOT

© 2017 Noah Aronson

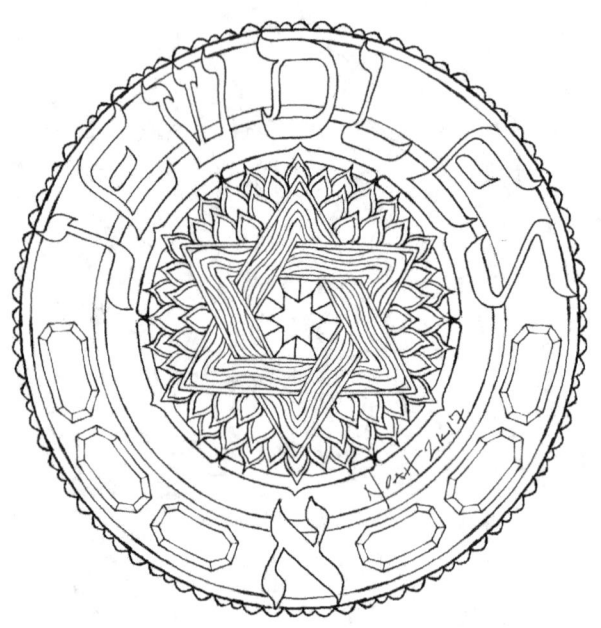

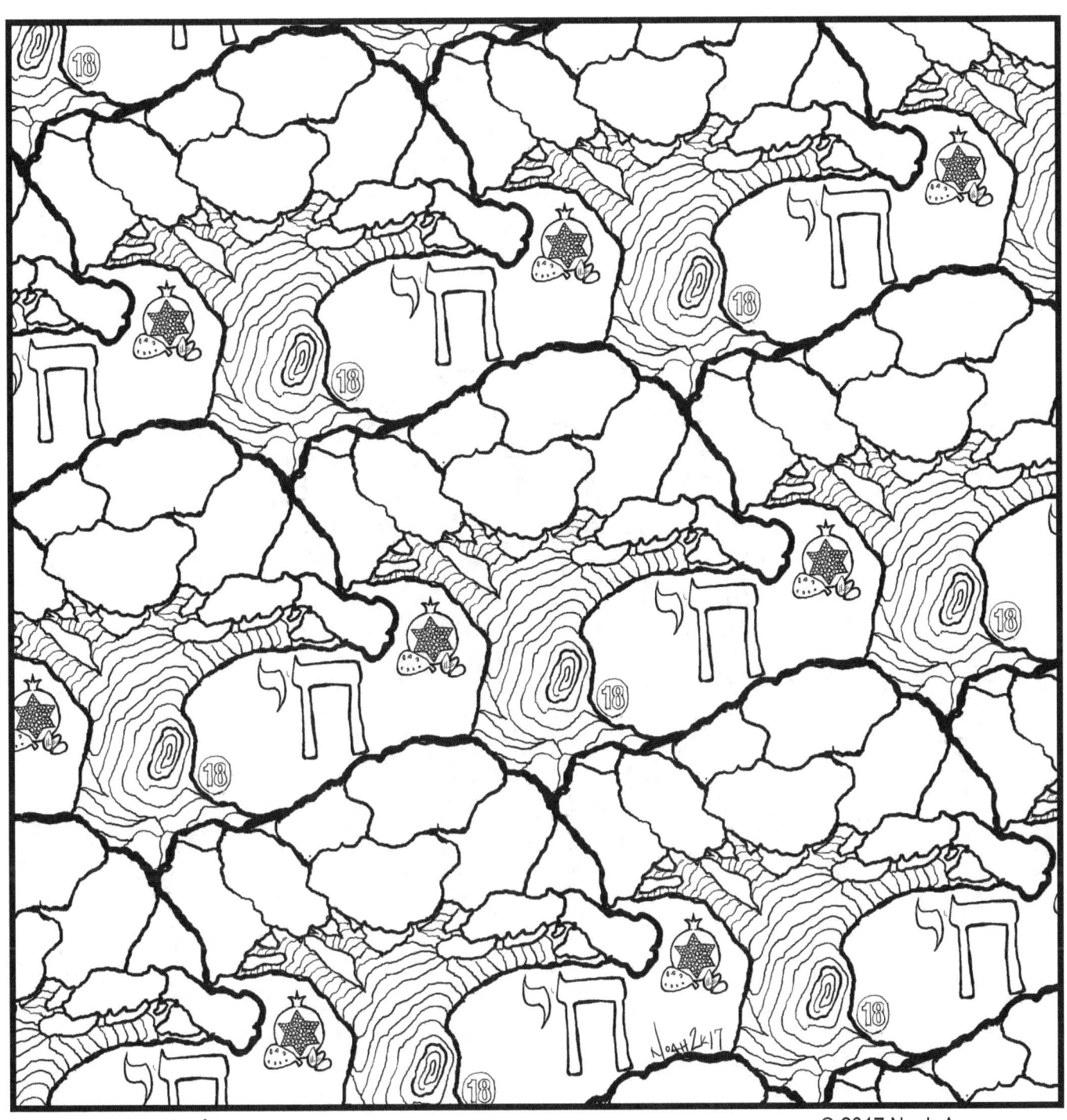

TU B'SHVAT

© 2017 Noah Aronson

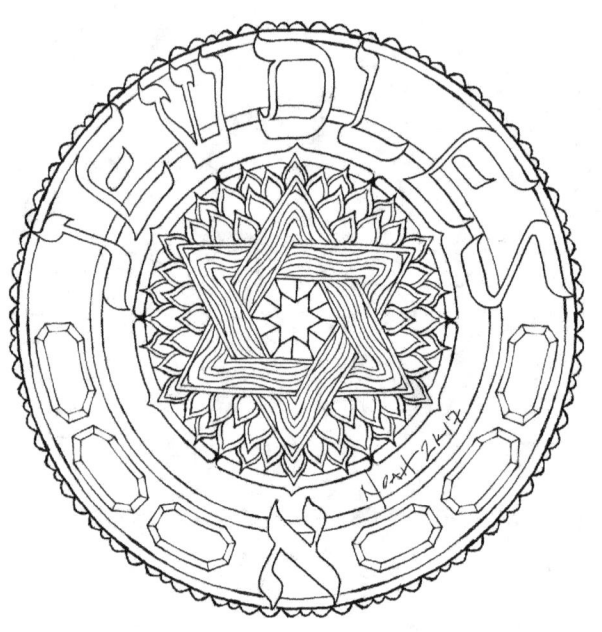

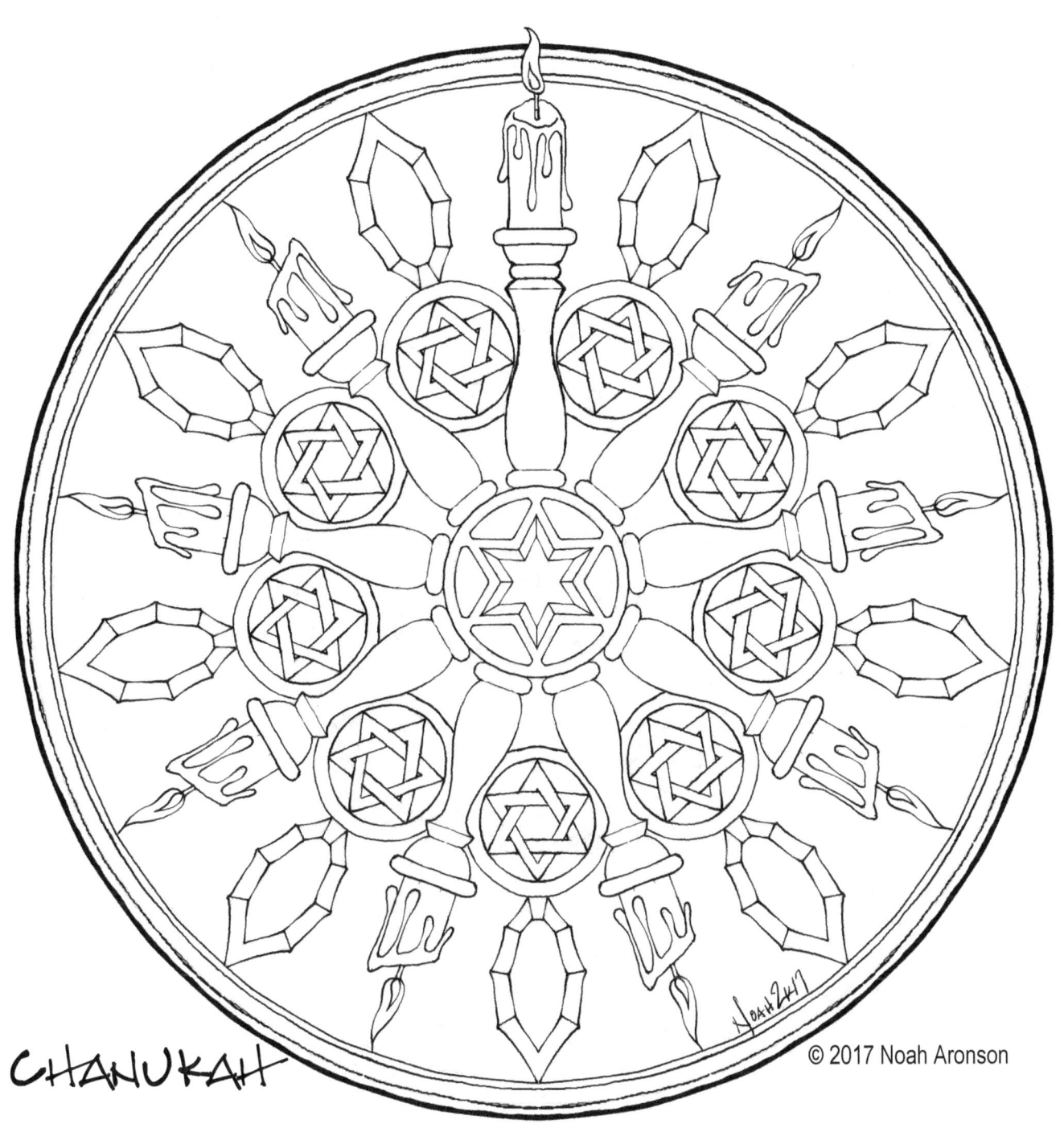

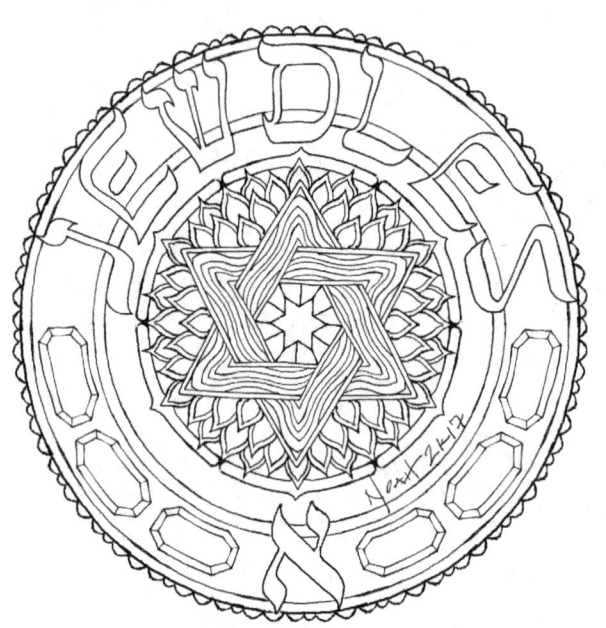

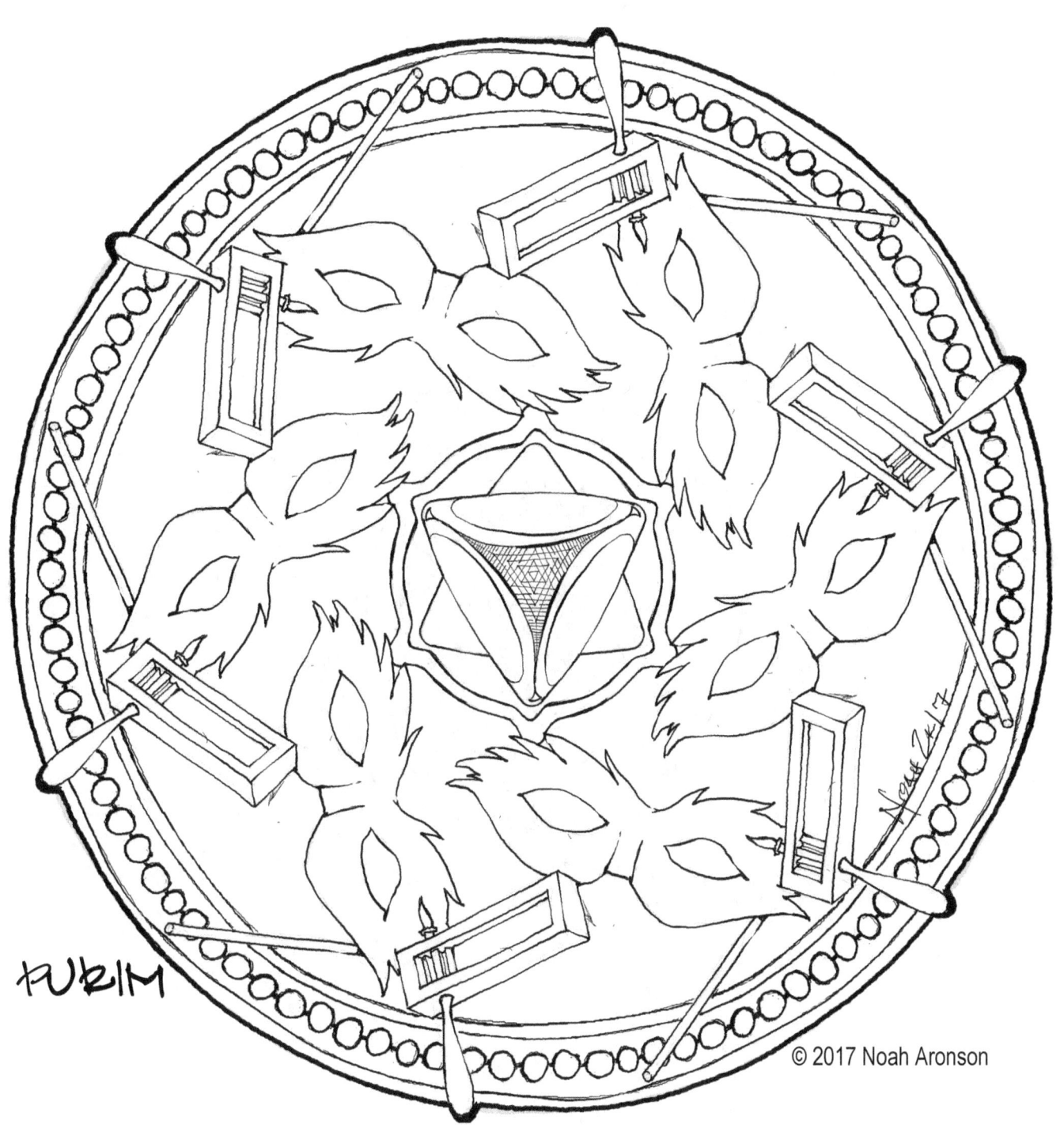

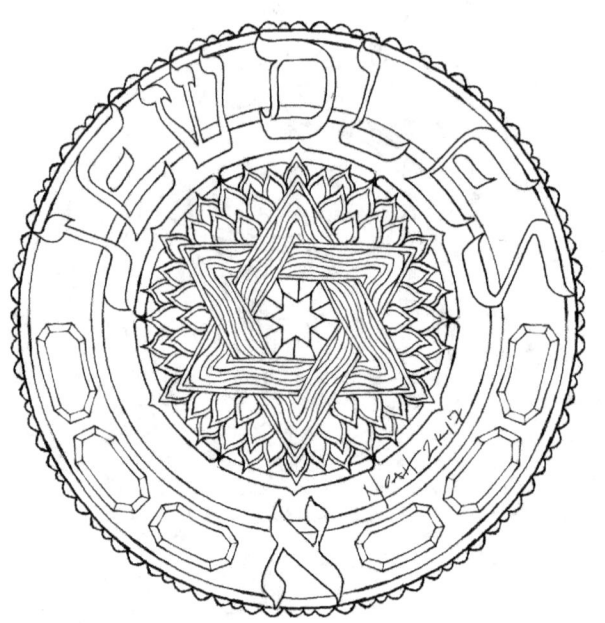

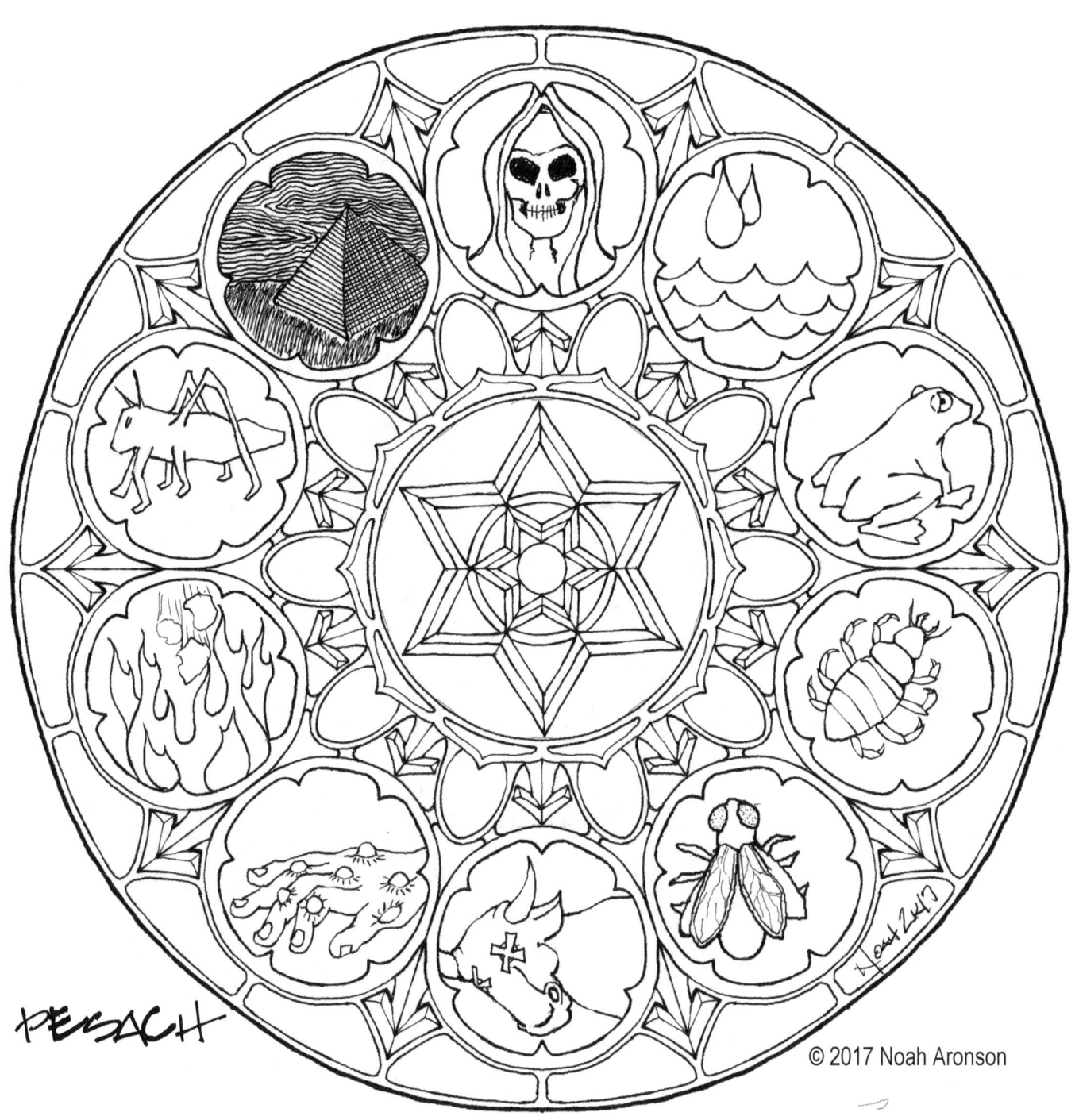

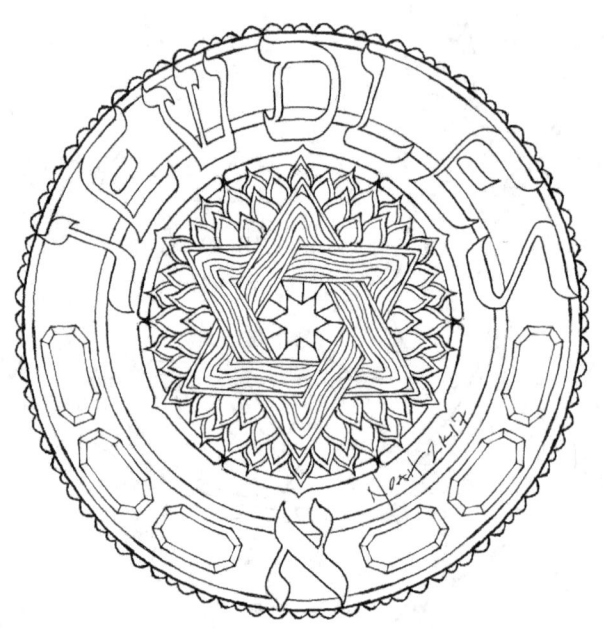

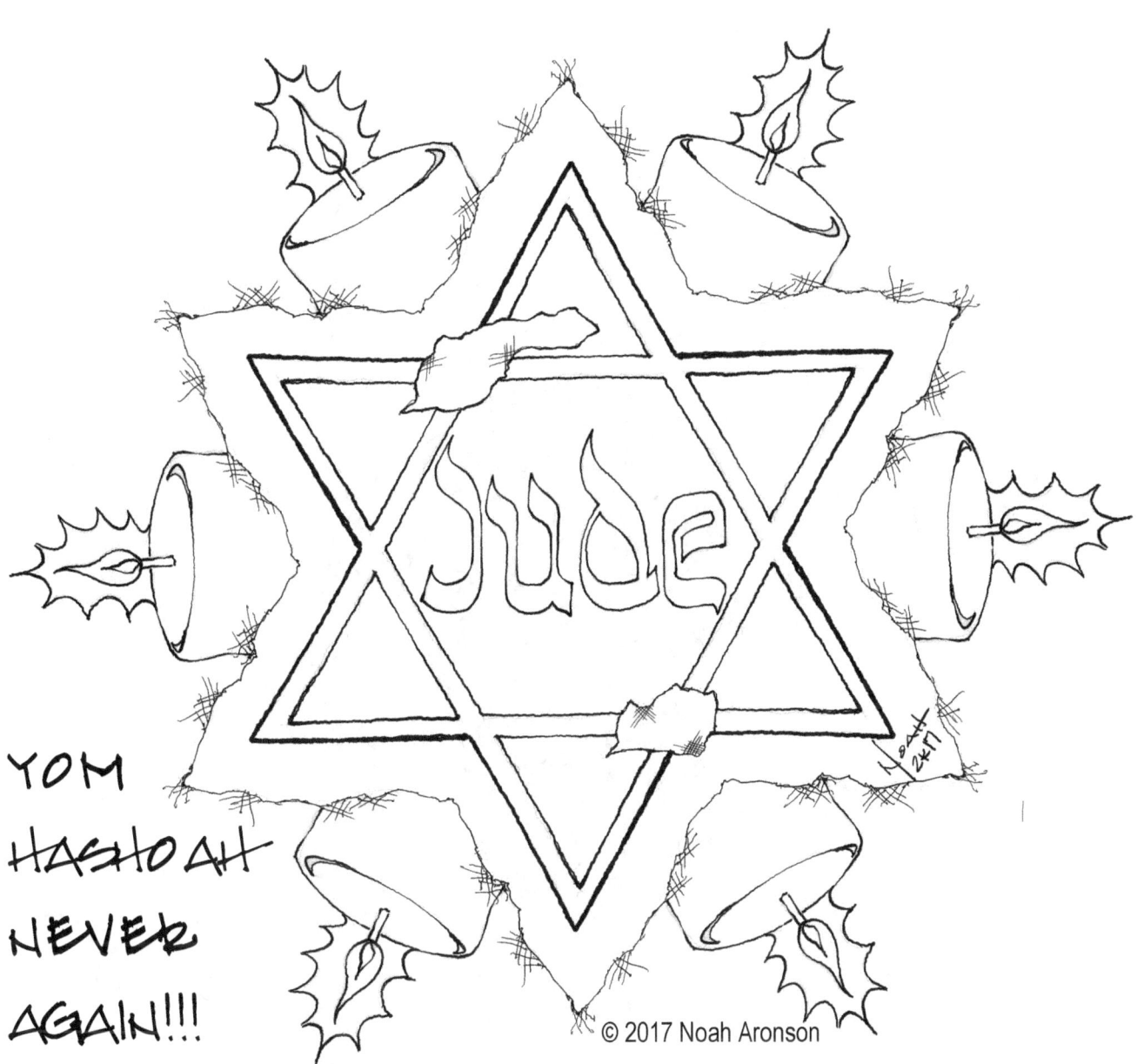

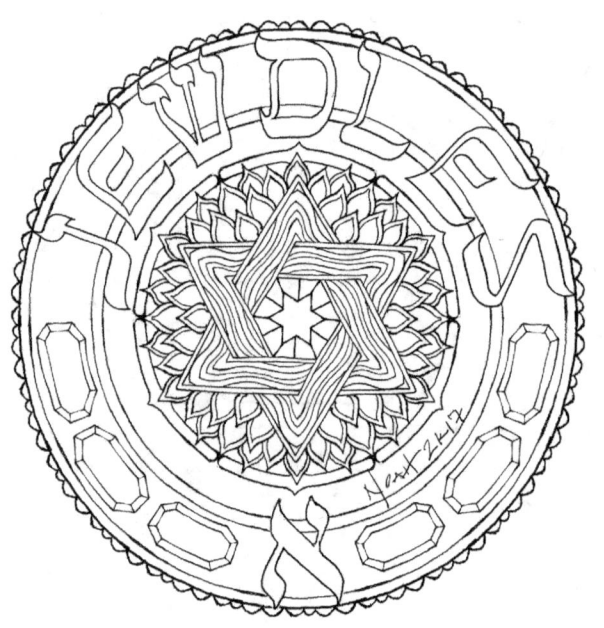

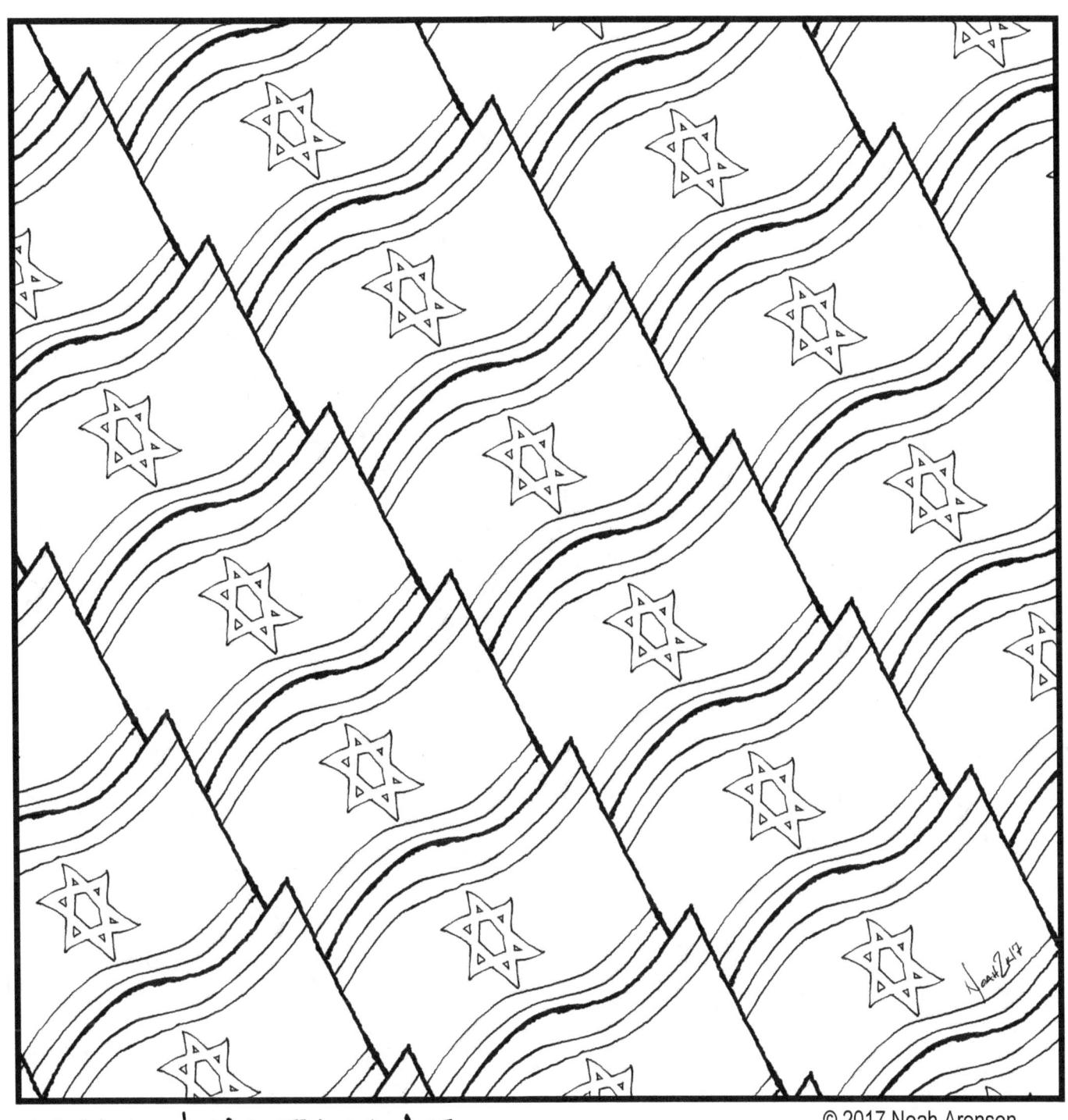

YOM HA'ATZMAUT

© 2017 Noah Aronson

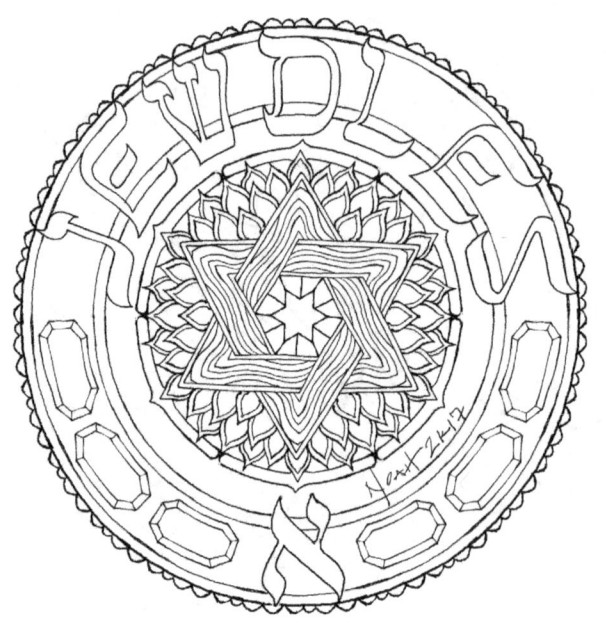

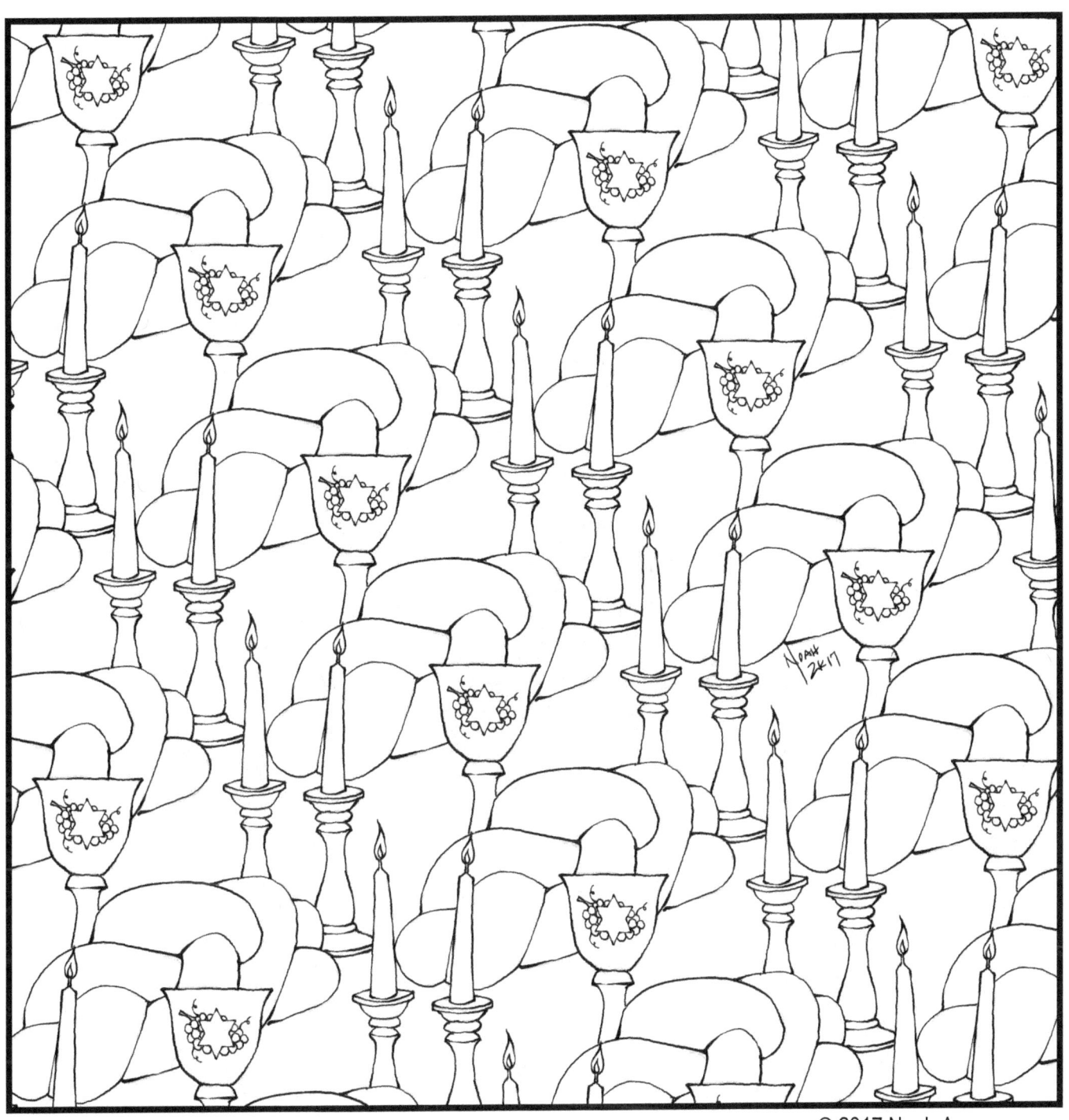

SHABBAT

© 2017 Noah Aronson

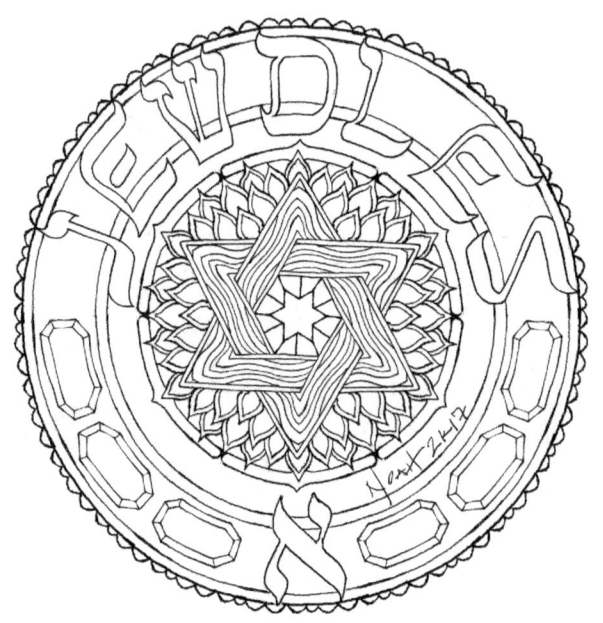

www.ingramcontent.com/pod-product-compliance
Lightning Source LLC
Chambersburg PA
CBHW060001230526
45472CB00008B/1903